HOW TO READ
FASHION

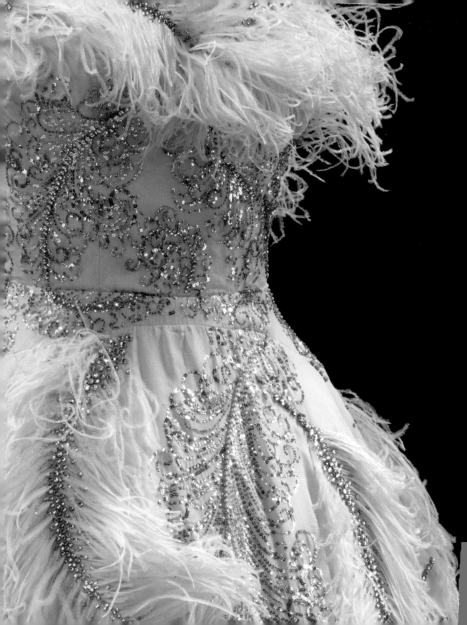

HOW TO READ
FASHION

A crash course in understanding styles

B L O O M S B U R Y

LONDON · NEW DELHI · NEW YORK · SYDNEY

Fiona Ffoulkes

First published in Great Britain 2010 by
Bloomsbury Publishing Plc
50 Bedford Square
London WC1B 3DP
www.bloomsbury.com

This edition published in 2013

ISBN: 978-1-4081-2839-8

Printed in China

Cover Images
Front cover: © John French, V&A Images,
Victoria and Albert Museum.
Back cover: © V&A Images, Victoria and Albert
Museum. Courtesy of Vivienne Westwood.
Back flap: © V&A Images,
Victoria and Albert Museum.

This book was conceived, designed
and produced by

Ivy Press
210 High Street
Lewes, East Sussex
BN7 2NS, UK
www.ivy-group.co.uk

CREATIVE DIRECTOR Peter Bridgewater
PUBLISHER Jason Hook
EDITORIAL DIRECTOR Caroline Earle
ART DIRECTOR Michael Whitehead
DESIGN JC Lanaway
PICTURE MANAGER Katie Greenwood
EDITORIAL ASSISTANT Jamie Pumfrey

Contents

**Platform shoes
(Ferragamo), 1938**
These rainbow
sandals of gold
leather with a
suede-covered cork
sole have been
revived in a
limited edition.

Fashion is everywhere and never has there been so much media coverage: from ready-to-wear to designer collections to red-carpet glamour. Such an incredible range of styles can be bewildering. Is this an original design or is it a revival style, like Gothic or neoclassical? Perhaps the two are mixed together and produced in an unexpected material, such as leather or metal. Fashion might reinvent the past by either fusing or reinterpreting styles, but it is always innovative.

Today, there are an infinite number of possibilities because creative ideas can derive in equal measure from history, the sports field, or the street—witness the temporary tattoos being produced in 2010 by the luxury fashion house of Chanel. With many companies outliving their founding members, their archives provide a rich source of inspiration for modern designers. John Galliano, for example, has produced his version of Christian Dior's famous 1947 New Look jacket,

while Ferragamo has revived its original Rainbow-Sole sandals from 1938—these are thought to have been created for one of his famous show business clients, Judy Garland.

Unique individuals—designers or their clients, from our present or a past era—can become role models and fashion leaders. From Josephine Bonaparte and Brigitte Bardot to Beau Brummell and Brad Pitt, the style setters have always been people with a public role, celebrities followed by the media. The effortlessly well-dressed Grace Kelly gave her name to possibly the most famous purse in history, the Kelly Bag, which was made by Hermès in the 1950s.

Grace Kelly, 1950s
Fashion can be about inventions, like the new Capri pants seen here, but is also about celebrity role models. As both an actress and Princess of Monaco, Grace Kelly's formal or informal elegant style has continued to inspire others.

Male celebrities, such as Cary Grant and Fred Astaire, were known for the elegance of their formal tailored clothes. Whether from London's Savile Row, Milan, or New York, men's style has been dominated by interpretations of traditional garments: from tailcoats to pants. Since the impact of the youth market in the 1960s, certain designers have been particularly significant in pushing boundaries; from the casual chic of Giorgio Armani to the extreme silhouettes of Hedi Slimane and Raf Simons.

Male and female fashions are always related and, although historically female dress has appropriated garments from men's wardrobes, recently—in the cut of clothes and the fabrics used—men's garments have also taken inspiration from women's clothing.

How To Read Fashion is a crash course in understanding contemporary styles and how they link to the fashions of the past two hundred years.

Pin-striped suit, 1970s
John Stephens sold fashionable styles for young men in his boutique His Clothes, Carnaby Street, London. This suit, worn by the milliner David Shilling, has wide shoulders and flared pants that emphasize the tight fit across the chest and waist.

This handy guide will help you to look for clues that will decode references to past fashions and the approach of particular designers. Arranged thematically, initial sections on recurring styles, materials, and techniques present the background before putting key garments, accessories, jewelry, hairstyles, and makeup under the spotlight while taking a closer look at some of the most important designers and brands.

This book aims to help the reader to appreciate current fashions and to enjoy a subject that is endlessly fascinating, not only because it draws on our shared history but because it expresses the times that we live in, our technological advances, even our individuality. Above all, *How To Read Fashion* celebrates the opportunity to have fun with the way we dress.

Christian Dior Y line, 1955
The shapes that Dior created continued to inspire its company designer from 1996 to 2011, John Galliano. Notice the close-fitting boned bodice and full skirt supported by seven layers of silk tulle and nylon net, with additional tulle at the hips.

Grammar of Styles

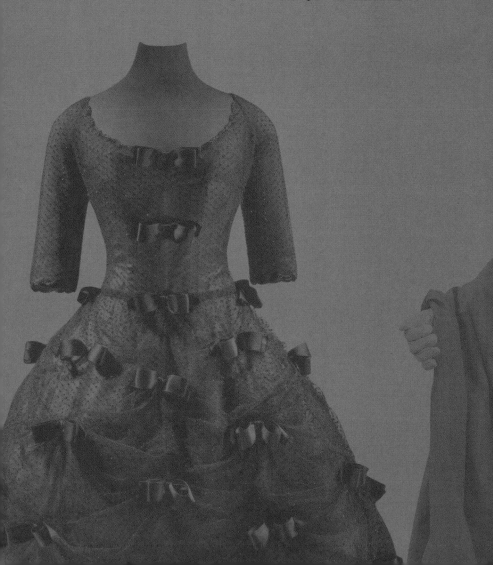

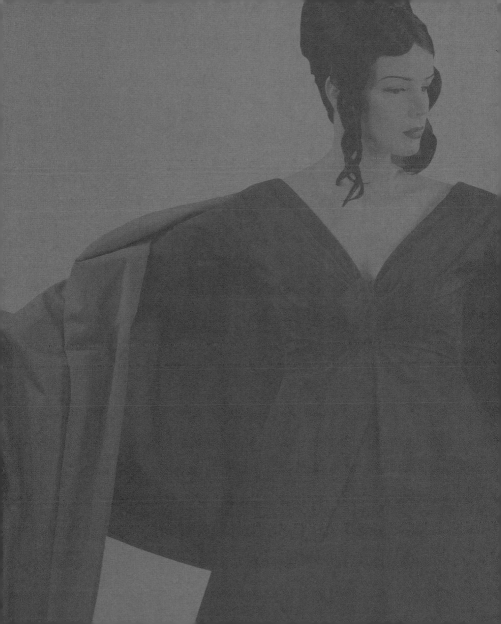

Introduction

Haute couture evening dress, 1923

This 1923 evening dress demonstrates the high-quality hand stitching used in haute couture. The colorful silk and velvet appliqué embroidery reflects the style of the costume designs Natalia Goncharova also created for the Ballets Russes.

The top fashion houses have always utilized the past to reinvent their new designs, referencing historical details for a wealth of different reasons. The classical and 18th-century styles may be seen as representing some pinnacle of excellence, while others, such as Gothic, incorporate ever-widening interpretations connected to history, art, literature, and movies. Fashion revivals might inspire fashion trends, but they are never "costume" because there are always technical, social, and cultural factors that transform the original concept into something new.

Art, 1938 (right)

This Elsa Schiaparelli evening dress of viscose, rayon, and silk with matching appliquéd veil is from her 1938 Circus Collection. Printed with pink and magenta trompe l'œil rips and tears designed by the artist Salvador Dalí, the Tear dress is an example of the relationship between fashion and surrealism.

17th century, 2006 (below)

In the search for rich textures, this evening dress from Christian Lacroix's haute couture fall/winter 2006 collection was entirely constructed from bands of lace and braid in shades of gold. The design was inspired by the 17th-century paintings of the Infanta by Spanish artist Diego Velásquez (1599–1660).

18th century, 2009 (below)

Since his days as a fashion student, John Galliano has referenced the 18th century in his designs. This outfit was inspired by the paintings of Thomas Gainsborough (1727–88) and the attitude of British musician Pete Doherty. The styling is historical, but the vest fabric and cut is modern.

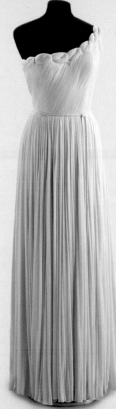

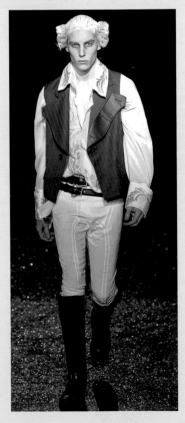

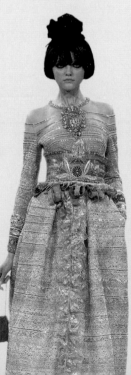

Neoclassical, 1955

This is the kind of apparently seamless gown, based on classical drapery, that French couturier Madame Grès was known for. There are thirteen panels of silk joined and minutely pleated, over a bodice that is boned and wired.

Historical

Masked ball, Dior 1958
Yves Saint Laurent designed this black tulle dress for Dior, and it was bought by the Duchess of Windsor. The style, construction, and bow decoration were inspired by the skirts of the 1860s.

Fashion may borrow textiles, patterns, and decoration from the past, but the clearest historical connection can be seen in the shape of women's clothes. Despite the modern woman's wardrobe being based on comfortable garments, the fascination with extreme shapes has continued, particularly for evening wear. Boned and stiffened structures, such as corsets, crinolines, and bustles, have continued to appear in modern collections.

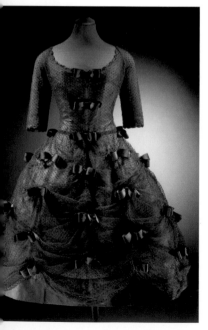

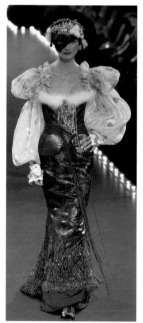

Christian Lacroix, 2001
In this evening outfit, Lacroix combined a 19th-century corset in bronze leather, edged with white fur, and an 18th-century neckline in pale green printed chiffon. The skirts are of embellished blue/red lamé and bright blue satin.

Muslin dress, 1820 (left)

There are two historical references in this high-waist muslin dress. The gathered collar was inspired by the ruffs of the 16th century and the series of puffs down the sleeves were named "Marie" after the 17th-century Queen of France, Marie de Medici.

Molyneux, 1939 (right)

This silk gown by Edward Molyneux demonstrates the range of styles being designed in the late 1930s as an alternative to the clinging bias-cut gown. Here, the skirt shape, with a double-tiered layer held out by four bone hoops, is from the 1580s.

Jacques Fath, 1948 (above)

This silk Jacques Fath evening dress has the prominent shoulder line of the 1940s. However, the skirt is held out over a crinoline petticoat and the train at the rear is looped up to form a tiered 19th-century style bustle.

Gothic

Joanne of Castille, 1496
Joanne, heiress to the Kingdom of Spain, is dressed in a gown and cloak of patterned wool or velvet, which is trimmed with royal ermine. These fabrics continue to inspire designers.

Originally referring to the medieval period, Gothic has been interpreted as a style in dress in a variety of ways. From the early 19th century, women's dress took inspiration from the rich textures of velvet and fur worn with gold and enamel jewelry fashioned in the form of skulls and crosses. However, there is the darker interpretation linked to mourning and horror stories, which is recognizable in the use of feathers, black leather, and lace with motifs such as bats and crows.

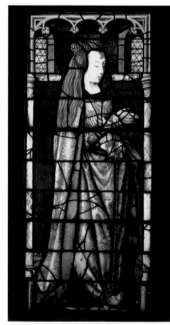

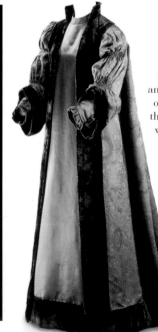

Liberty gown, 1897
Medieval shapes and fabrics inspired this gown by Liberty of London. References include the sunflower and pomegranate motif on the rich gold fabric that echo 15th-century woven velvets and the plush velvet bands that resemble fur.

Night Music, 1956 (below)

Dior gave this silk faille outfit its romantic name. Posed here to mirror the photograph taken by Richard Avedon for *Harper's Bazaar*, this is a sexy theatrical concept—a vampire who is about to swoop down and seduce her victim.

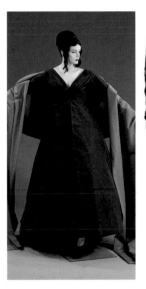

Spider motif, 2010

This short silk dress by Giles Deacon is printed and embroidered with large spiders. It reflects Deacon's personal interest in gardening, but it alsoshocks because of the deep-seated human fear of spiders.

Wraith, 2010 (right)

Gareth Pugh, who is known for his Gothic styles, presents a dramatic look on a pale-faced model, which is resonant of horror movies. Here, under a bolero jacket, the lines of chain mail looped across the chest resemble the shredded clothing of the undead.

18th Century

Dress, 1878
This princess line dress has a lace-trimmed, square neckline with a ruched front panel that together create the effect of an 18th-century gown. The literary character Dolly Vardon, created by Charles Dickens (1812–1870) in the novel *Barnaby Rudge*, helped to popularize many 18th-century styles.

Whether it is the extravagance of Versailles, high hairstyles, floral fabrics, ribbon motifs, or extreme shapes, women's 18th-century dress has continued to inspire designers from Worth to Westwood and Galliano. Men's dress has been equally inspired by romantic descriptions of highwaymen and pirates. Ponytails, full-sleeved shirts, and high boots were popular in the 1960s, and again in the 1980s.

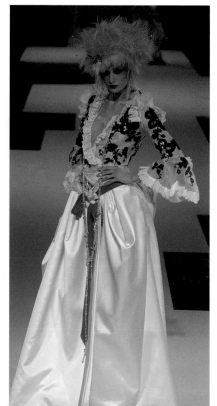

Christian Lacroix, 2003
Lacroix transforms 18th-century references, such as the shape of the bodice and flounced sleeve, into a light, wearable style by using contemporary fabrics. The accent colors of green and pink contrast with the drama of the black and white in the blouse.

Hat, 1870s

Dickens' 18th-century heroine, Dolly Vardon, wore a hat like this in *Barnaby Rudge* and made it fashionable. This French version has the defining characteristics: a circular flat straw hat shape, trimmed with silk flowers and ribbons.

Prada, 2010 (below)

Fashion trends are also inspired by architecture and the decorative arts. Here, Prada produced a sandal that evokes the luxurious chandeliers of Versailles but using the modern materials of perspex and PVC.

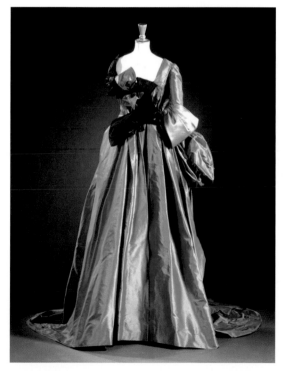

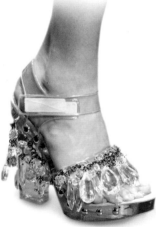

Vivienne Westwood, 1996

In a sculptural approach to design, Westwood's silk evening dress looks like an 18th-century formal sack-back gown from the left, complete with a polonaise pouf. However, if seen from the right, it becomes a sleeveless 1990s style.

Classical & Neoclassical

The style of dress favored by the ancient Greeks and Romans is known as classical. There have been many revivals of this style, called neoclassical, each mixing decorative elements from the original period with contemporary fashion. Classical elements extend to color, pattern, and jewelry, but most identifiable is the draping and pleating of the fabric around the natural contours of the body. This distinctive form of pleating flatters the silhouette and is applicable to the fashionable shape of any period.

Neoclassical dress, 1950s
This silk chiffon red evening dress designed by Jean Dessès in 1953 demonstrates how the pleating typical of classical dress was applied to the corseted shape of the 1950s. Dessès became known for this technically brilliant, although seemingly simple, glamorous goddess style.

Neoclassical dress, 1912

Mariano Fortuny rejected corseted fashion and created clothing inspired by the classical style with simple adjustable pieces that gave freedom to the body. In 1909, he patented the first version of a pleated sheath dress called "Delphos." This outfit is a variation with a shorter tunic and weighted hem.

Neoclassical style, ca. 1800

Empress Josephine's curls and diadem echo the classical ideal. Her dress is less authentic, combining the high waist and fitted bodice of the 19th century with classical sleeves. The newly fashionable cashmere shawl echoes a Roman *palla*.

Classical dress, AD 400

Authentic Roman dress is depicted on this panel from AD 400. The priestess wears a full-length tunic, or *stola*, with a cloak, or *palla*, draped over her shoulder. Clothing was draped and folded; held together by knots, brooches, pins, or belts; and had weighted hems to create the ideal fusion of form and fabric.

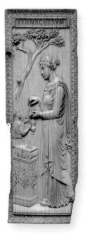

Neoclassical, 2009

This 2009 silk chiffon dress by Alice Temperley is based on a worker's tunic from classical times. It has a drape on the left shoulder, like the Roman priestess, combined with a contemporary silver belt and beaded decoration.

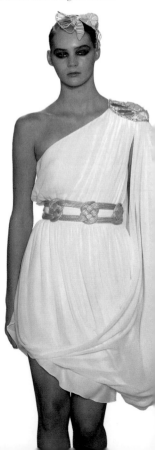

Empire

Dior, haute couture, 2005
This organza dress and duchesse satin cropped jacket is embroidered with silver thread and was inspired by the court dresses and trains worn by the Empress Josephine (1763–1814). John Galliano called the voluminous designs "fertility" dresses.

The Empire line describes a high-waist straight, or A-line, silhouette. The name refers to the French empire (1804–1814) of Napoleon I, when Empress Josephine and her designer Louis-Hippolyte LeRoy established new fashions at court. Modern interpretations have included her neoclassical hairstyle of curls framing the face, rose decorations, puffed sleeves, and fine silk dresses embroidered in colored silk, silver, and gold thread.

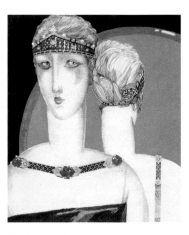

Cartier, 1926
Cartier's tiara is worn low on the forehead as they were during Napoleon's empire, but the combination of materials—probably platinum, lapis lazuli, onyx, and diamonds—is specific to the art deco style of the 1920s.

Poiret, 1912 (below)
Paul Poiret's model wears a high-waist day dress in a Chinese floral fabric that echoes the shape of Empire dress.

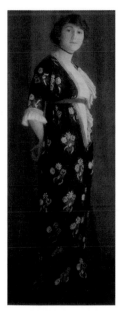

Dolce & Gabbana, 2006 (below)
A formal coat based on the embroidered dress worn at Napoleon's court has been given a casual look. Empire green was used to decorate the emperor's apartments and was also the color of his robe when he was crowned King of Italy.

Luella Bartley, 2010 (right)
This dress is based on a 1960s minimalist interpretation of Empire style. It has a high waist defined by a black bow that draws attention to the fitted bodice. However, the skirt resembles the curved silhouette of the late 1950s.

Exoticism—Japan

Japanese style and culture have had a profound effect on Western art and dress, particularly in the late 19th century and the 1980s. Japan opened its borders to the world in 1854, and from that time the impact of Japanese style could be seen in the West, mostly recognizable in the kimono T shape and highly decorated fabrics. Then, in Paris during the 1980s, Japanese designers, including Issey Miyake and Yamamoto, reworked their traditions and produced a silhouette that was different from Western dress.

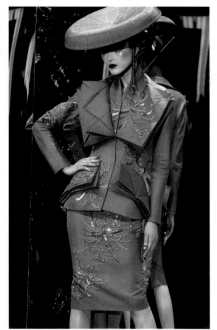

Evening dress, 1891 (above)
Elements of Japanese design were evident in dress fabrics in the late 19th century, after Japan had opened its borders to the West. This textile shows their distinctive style of dramatic contrasts with clear forms, vivid colors, and black backgrounds.

Dior, 2007
This vivid pink suit was part of John Galliano's haute couture collection, which fused the glamour of *Madam Butterfly* with the angular shapes of origami. Complex paper folds are cleverly translated into fabric that is quilted as well as embroidered.

Layered clothing, 1996 (right)

Shirin Guild designed a layered linen outfit including a vest and two jackets. Layering kimonos is the traditional Japanese method of displaying taste and status—with twelve kimonos being worn at a royal wedding in 1993.

Poiret, 1913 (above)

Paul Poiret was interested in simple shapes that freed the body, and in the exotic colors of Fauvism and the Ballets Russes. This yellow wool coat, which is based on a Japanese kimono, demonstrates his approach to design.

Alexander McQueen, 2006

McQueen plays with the conventions of evening dress by fusing a tailcoat with the less tailored shape of a wide-sleeve kimono. By using a bright silk, it also acquires a more flamboyant, less formal style.

Exoticism—Africa

Gaultier, 2005
Jean-Paul Gaultier is famous for his strong themes and the wearable interpretation of his ideas. The theme of this haute couture collection was the African Queen; African masks inspired this silk dress design.

The West has long seen Africa as an exotic place characterized by natural materials, bright colors, and wild animals, including zebras, lions, and leopards. Since the 18th century, leopard print has been a popular animal motif. Decorative elements of ceremonial dress using raffia, feathers, and beads have been applied to Western garments. Even wooden fertility statues have inspired modern designers, such as Jean-Paul Gaultier, to produce conical shaped bustiers and dresses.

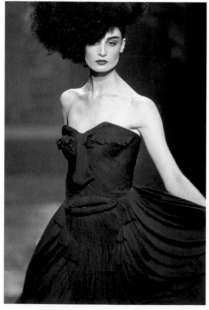

Evening dress, 1948 (right)
This fabric, printed in Manchester, England, to imitate batik, has been used by Matilda Etches to create a dress based on the wrapped clothing worn by West African women. In this interpretation, there is a boned foundation that supports the stiffened drapery across the bodice and front hip.

Fur coat, 1960s (right)

The pose of the model in this photograph reinforces the link between fur, wealth, and luxury. Jackie Kennedy made wearing a leopard skin coat fashionable when her designer Oleg Cassini suggested its adoption around 1964.

Evening dress, 1936 (above)

Colonial exhibitions and *Tarzan* movies helped to promote African-inspired fashions in the 1930s. This asymmetrical dress, designed by fashion house Busvine, has the figure-hugging shape popular at the time, emphasized by the diagonal pattern of the leopard print.

Dior jacket, 2009

John Galliano's Bar Jacket follows the general trend for animal prints with the less usual black-and-white stripes of the zebra. The pattern is cleverly positioned vertically and horizontally on the jacket, while the "ears" add a humorous touch.

27

Art

Art has had a strong impact on fashion since the 1890s, when aesthetic dress was created as a reaction to the restrictive clothing of the time. In the 1930s, the designer Elsa Schiaparelli worked with surrealist artists Dalí and Cocteau to create some unusual motifs for clothing, ranging from an upside-down shoe as a hat to a necklace of bugs. Since the 1960s, designers have used fashion both as a blank canvas and a conceptual opportunity.

Conceptual chic, 2010
Viktor & Rolf produced a gown that was based on the idea of cutting back during the credit crunch. This is interpreted by literally cutting the edges and a large hole through the many layers of tulle, an effect that astonishes and amuses.

Aesthetic dress, 1905
Aesthetic dress was adopted by people who rejected the harshly colored, tight dress of the time. This embroidered velvet dress does not restrict the body or its movements, and the muted mauve color was seen as harmonious.

Trompe l'œil, 2008

Sonia Rykiel's designs sometimes incorporate visual puns that owe much to surrealism. Here, the belt tabs are real, but the belt itself is only a flat image. Similarly, the butterfly loops of the bow are three-dimensional, but the hanging end is not.

Skeleton dress, 1938 (left)

Elsa Schiaparelli's 1938 black silk crepe dress, designed with Salvador Dalí, links surrealism and fashion. The close-fitting shape perfectly adheres to the conventions of the time, but the padded and quilted depiction of the spine and rib cage was designed to shock.

Mondrian dress, 1965 (right)

This cocktail dress designed by Yves Saint Laurent was part of a group of dresses inspired by the abstract paintings of Piet Mondrian (1872–1944). The simple shape provides a canvas for the design based on blocks of color divided by black lines.

Military

Band jacket, 2009
The Balmain designer Christophe Decarnin designed a series of jackets inspired by the "marching band" outfits worn by Michael Jackson in the 1980s. The extremely rounded shoulder line focuses the eye on the ornamental military braiding.

Functional and ceremonial military uniforms have long inspired the shape, cut, and decoration of clothes for men and women. This can be seen in the fabric, color, and pattern, such as khaki and camouflage, and in the use of bright colors, metal buttons, and braiding. By taking uniforms out of their normal context, designers can subvert their original messages of power and propriety.

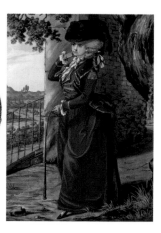

Woman in riding suit, 1780s
Robert Dighton's painting of a woman in a red riding suit demonstrates the military trend in women's jackets. The shoulders are emphasized by gold bullion epaulets and the jacket has a man's cut but is drawn back to form a bustle.

NATO camouflage suit, 1980s

In the late 1980s, the black militant look, B-boy style, was epitomized by the band Public Enemy, who dressed in uniforms similar to the NATO camouflage suit shown here.

Sgt. Pepper jacket, 2006

Hedi Slimane's *Sgt. Pepper*-inspired satin jacket was part of a 1960s-themed collection showcasing his tailoring skills and his signature skinny silhouette. Such theatrical jackets suited celebrity clients from the music and movie worlds.

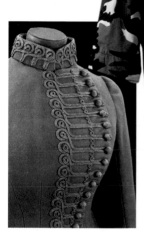

Riding jacket, 1880 (above)

Redfern, the tailoring company who made this flannel riding jacket, had a reputation for fashionable, practical women's clothing. This example is typical of their mannish style decorated with military-type braiding.

Garçonne—Boyish

Tommy Nutter suit, 1969
This jacket and vest, which had matching pants, were made for Jill Ritblat in Savile Row. The blouse by Yves Saint Laurent has a classic masculine stocklike necktie.

Traditionally, women's dress for practical sports such as riding, had been based on men's dress. However, the wearing of pants in the 19th century was the first real appropriation of masculine style and was linked with dress reform and votes for women. Then, in 1922, the heroine in a novel entitled *La Garçonne* by Victor Margueritte (1866–1942) demonstrated her belief in equality by cutting her hair short. Since that time, the boyish style has recurred with short hairstyles, ties, jackets, and pants.

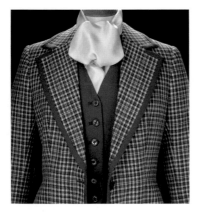

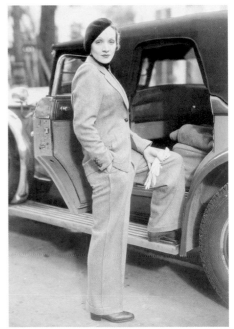

Marlene Dietrich, 1933 (right)
Actress and singer Marlene Dietrich helped promote the wearing of pants in the 1930s. She adopted mannish clothes, such as the tweed suit here. One critic said, "She has sex but no particular gender."

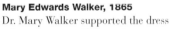

Mary Edwards Walker, 1865
Dr. Mary Walker supported the dress reform movement by wearing a man's formal frock coat and pants when awarded the Medal of Honor for her work as assistant surgeon during the American Civil War.

Ralph Lauren, 2006
Ralph Lauren demonstrates one of his signature garçonne looks, incorporating the trend for shorts as winter wear. The top half shows formal menswear with the 19th-century fashion of displaying the pocket-watch chain.

Rebels

Attitude, 1953
Marlon Brando represented the disaffected youth in *The Wild One*. His Schott Perfecto leather jacket, jeans, and boots became a kind of uniform for rebellion.

Rebel style is about wearing clothes that communicate attitude. Movies of the 1950s featuring leather-clad youths started this trend, which ever since has been reflected in clothing worn by bikers, punks, and rock bands. Clothing is often made of leather or denim decorated with rips, studs, and chains. The street-style fashion may be worn on a body adorned with tattoos and piercings, but in high fashion the look is about glamour.

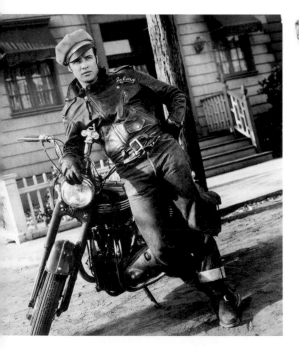

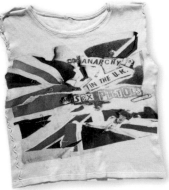

Punk, 1976 (above)
This sleeveless T-shirt was created by Vivienne Westwood in 1976. Westwood's partner, Malcolm McLaren, was also the manager of the Sex Pistols, and the provocative slogan across the flag typifies their nonconformist approach.

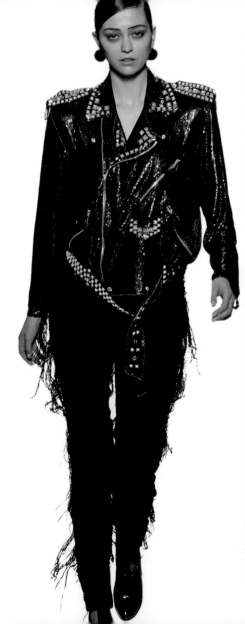

Biker, 2009

Gaultier challenges gender stereotypes, so it is typical in his designs to see a woman in a mannish garment, such as a biker's jacket. Here, the jacket is of high gloss leather, with decorative studs and military epaulets for a glamorous look.

Punk, 1977

Zandra Rhodes was inspired by the punk movement when she designed this rayon jersey dress. The rips on the bodice and skirt have been emphasized with blue stitching and decorated with beaded safety pins, ball-link chains, and diamanté.

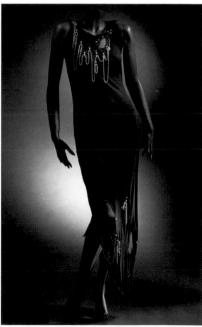

Inside/Outside

Gaultier crinoline, 2008
Gaultier often experiments with crinolines. In this example, where a leather cage with ornate buckles is worn over a fur coat, it is more about protecting luxury than supporting petticoats.

The trend for revealing or suggesting underwear has shocking, forbidden, and exciting connotations. Designers have played with traditionally hidden garments in male and female design to create provocative fashion. Much inspiration comes from historical dress and its supporting structures, such as corsets and crinolines, as well as body-revealing chemises and slips produced in delicate silk and lace.

Moschino bra dress, 1988
Moschino was known for his provocative and amusing clothing that was nonetheless flattering to the body. These qualities are displayed in this cotton and polyester evening dress, constructed of a black petticoat with twenty bras.

Gianfranco Ferre lace gown, 2003 (right)
This Italian designer was known for using strong shapes, colors, and luxurious fabrics. Here, fine black lace creates a revealing evening gown inspired by the Napoleonic period, through which the understructure of panties and corselet can be seen.

Strapless satin gown, 1950s (below)
The short, strapless evening dress worn by actress Jane Russell here suggests lingerie in its use of fabric—patterned white silk trimmed with lace. The delicate effect disguises the complex structure of boning that underpins this figure-hugging and glamorous gown.

Worth Tea gown, 1900
Tea gowns were fashionable "at home" wear in the late 19th century. They were less structured than other garments and were a showcase for the delicate fabrics and lace normally used in lingerie. For this gown, Charles Worth used satin, chiffon, and lace.

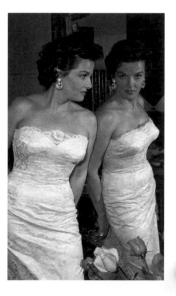

Christian Lacroix, 2004

Christian Lacroix has a reputation for the most creative and luxurious haute couture garments. This dress also shows the workroom skills necessary to produce layers of hand-painted silk fused with a deconstructed corset.

Before 1959, when fashion houses in Paris started to introduce prêt-à-porter (ready-to-wear) lines, models of garments were sold to different clients, from individuals to mass manufacturers. Today, a haute couture garment describes a design adapted from a catwalk model to a client's specification and measurements. Valued as an art object, made of luxurious fabrics and highly decorated, the construction of each garment involves many hours of skilled handwork and at least three fittings.

Haute couture model, 1955

This label demonstrates how fashion houses operated commercially before they created their own prêt-à-porter collections. This fashion business, Marie Thérèse in Nice, France, has paid for the right to reproduce the Nina Ricci original.

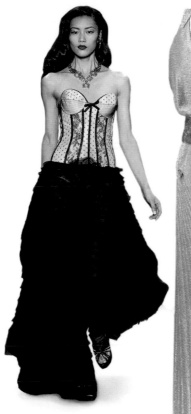

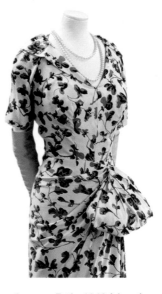

Jean Patou, 1932–4 (left)
This dress can be compared with a piece of sculpture, where every viewpoint has been considered. The neoclassical style is created from bead-covered tulle that disguises seams and creates a trompe l'œil effect of drapery.

Dior, 2010 (above)
John Galliano has often spoken about the role of the haute couture collection in leading the house style. This prêt-à-porter evening dress, which is based on the corset, is similar to but less luxurious than the haute couture dress shown in the Ball Gown section (see pages 94–95).

Jacques Fath, 1949 (above)
This haute couture dress illustrates the hourglass designs of Jacques Fath, who draped fabric around his models to create his clothes. The owner of this dress, Lady Alexandra Howard-Johnston, promoted his clothes at society events.

Techniques

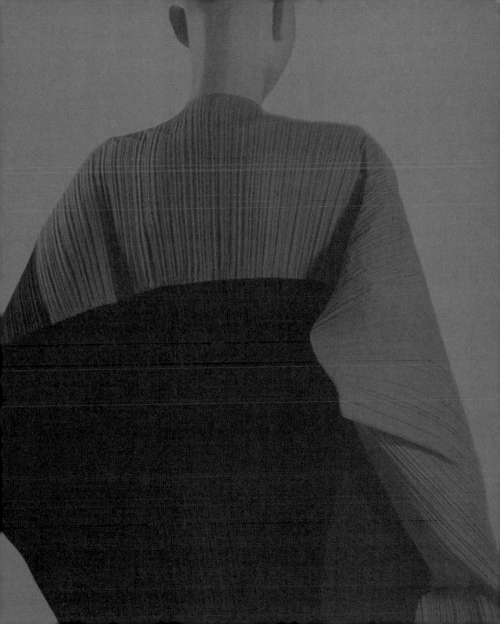

Introduction

Technical knowledge about fabrics, construction, and decoration has evolved over time, and there are many specialists, from designers and tailors to embroiderers, who each contribute their expertise to a garment. Mechanization of looms and the invention of the sewing machine in the mid-19th century all affected clothing production. However, in the luxury clothing sector, new fabrics and ideas have been embraced in the 21st century, alongside the continued veneration of traditional, skilled handcrafts.

Hunting jacket, 1860–90
The gilt brass buttons on this superfine wool dress coat have the initials H. H. on them, signifying that the wearer belonged to the Hampshire Hunt. These buttons are more than decoration, because they show membership of an exclusive club.

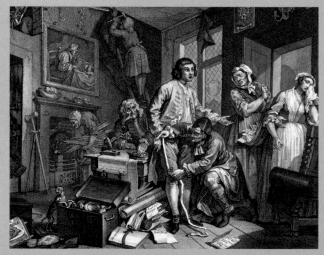

The Rake's Progress, 1735
Hogarth's Tom Rakewell is being measured by a tailor. In keeping with the first important work on tailoring by Garsault (1769), a strip of paper is placed on the body and each measurement is marked with a snip.

Wedding dress, 1934
This ivory silk satin dress designed by Charles James fits the body perfectly due to its fine fabric, cut, and construction. There are five short darts that fit the yoke to the main part of the dress, and the long darts running from back to front beautifully shape the hips.

Boating suit, 1890 (below)
This jacket and matching vest in pin-striped flannel fasten with buttons of bone. The stripes have been perfectly matched by the tailor at the collar, patch pocket, and vest sides.

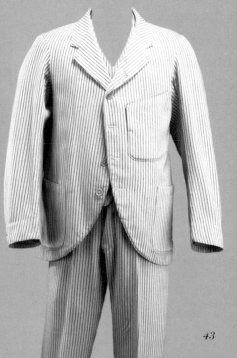

Spencer jacket, 1818 (above)
The Gothic-style puffed sleeve of this woman's blue velvet jacket is trimmed with satin-faced matching bows and lined with linen throughout. Both are difficult fabrics to work with because they slip, and this detail is a testament to the dressmaker's skill.

Tailoring

Tailoring is an approach to the construction of menswear that was also used in riding clothes for women before being extended to other formal outfits. Various technical systems for cutting clothes were developed in the 19th century, based on geometrical rules related to the proportions of the body. Layers of canvas, wadding, and pads, plus the skilled use of an iron, mold a shape that emphasizes areas such as the shoulders and chest, disguising any imperfections.

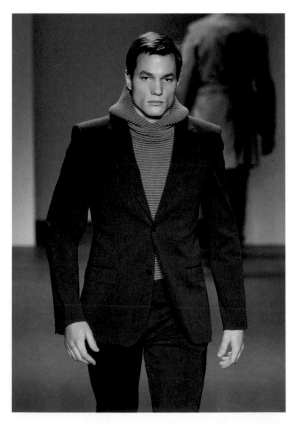

Calvin Klein, 2010
The history of American tailoring refers to the Ivy League look, which is elegant, youthful, sporty, and less stuffy than Savile Row. This Calvin Klein suit worn with a thick ribbed, sweater, shows sharp tailoring styled informally.

Savile Row, 1964 (right)

This suit from Anderson & Sheppard involved different specializers for the jacket, vest, and pants. The jacket has a smooth, slightly extended shoulder line, and the strong horizontal bands of the Glen Urquart check are perfectly matched.

Reefer jacket, 1890s

This woman's jacket is made of box cloth and trimmed with silk Russia braid. It is based on the masculine Reefer jacket and shows the smooth line across the chest with the crisp cut and stitching found in men's tailoring.

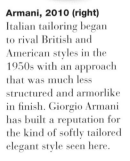

Frock coat, 1890s

To create a smooth line at the back of the coat, wadding has been inserted from the bottom of the armhole to the waist. It is held in place between the silk lining and superfine wool by tiny prick stitches on iron-pressed squares.

Armani, 2010 (right)

Italian tailoring began to rival British and American styles in the 1950s with an approach that was much less structured and armorlike in finish. Giorgio Armani has built a reputation for the kind of softly tailored elegant style seen here.

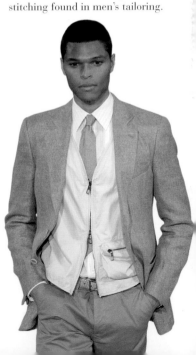

Dressmaking

Princess line

This 1955 silk faille dress, worn by Margot Fonteyn, makes use of the princess line cut in order to emphasize the inverted Y shape of Dior's design. This is a method of cutting vertical pattern pieces that does not require a waist seam.

The making of women's clothes has evolved from cutting fabric directly on the body in the 18th century to drafting a flat paper pattern or creating a fabric toile on the stand. By the late 18th century, a one-piece dress was possible, and throughout the 19th century, different techniques were tried to fit cloth to the shape of the body. In the 1920s, Madeleine Vionnet developed the cutting of lightweight fabrics on the cross-grain, or bias, so that they clung to the body.

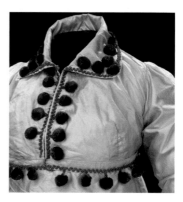

Bust dart

These darts can be seen on this silk Spencer jacket, shown with a matching dress from ca. 1807. It is not known exactly when bust darts were invented, but they do represent the development of dressmaking skills toward a better fit to the body.

Bias cut (right)

Lanvin's 1935 haute couture dress is made of purple satin that is cut on the bias and machine sewn. The classical, sculptural quality of the dress is emphasized by the sheen of the satin and the cut, which allows the fabric to flare out below the hips.

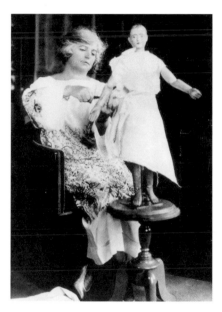

Madeleine Vionnet, 1935

Vionnet was a uniquely skilled and inventive designer/dressmaker who worked out her designs by draping and cutting fabric on a miniature model. To produce light, supple garments, she developed the cut of geometric shapes on the warp, weft, and bias.

Diamond-shape panel (below)

The diamond-shape panel in this 1805 striped silk dress shows clearly the straight grain of the fabric running vertically at the center back. The side panels use the cross-grain, or bias, cut, which gives more stretch and accommodation to the body.

Shape & Fit

The overall shape of a garment depends on the underlying structure, the cut of the fabric, and the construction. Color, texture, and decoration can emphasize this form. From the late 15th century until the 1910s, women's clothes were usually constructed to fit over a body shaped by a corset and pads or caged petticoat. From the 1920s, a more natural body shape was fashionable and soft, lightweight fabrics clung to the body. However, since the 1930s, designers have experimented with structure and continue to produce exaggerated shapes.

Asymmetrical, 1986 (left)

Anthony Price's asymmetrical silk taffeta bird's-wing dress demonstrates his reputation for rock-star glamour. Here, he evokes the image of a bird by using large folds of fabric moving up the body, which sweeps beyond the shoulder to suggest movement.

Boned bodice, 1890

The internal back view of this Worth silk gown demonstrates the complex methods of construction that had developed by the late 19th century. Note the boning and the waist tape that fastened at the front, anchoring the bodice to the body.

Bustles, 1885 (above)
In this fashion plate from *Myra's Journal*, two women are wearing day dresses that are held out at the back by large bustles. The supporting frame holds out the fabric of the dress, an effect that is exaggerated by folds and poufs.

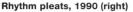

Rhythm pleats, 1990 (right)
Issey Miyake is known for his sculptural pieces based on geometric shapes made out of pleated fabric. This example, which was designed to shift with the body's movements, was created from pleated polyester rectangles.

Padding, 1937
This Charles James evening jacket uses the same technique as an eiderdown quilt. The satin shape is filled with down, but in order to facilitate the movement of the body, the depth of padding is reduced at the neckline and the armhole.

Lining & Finishing

Machine stitching, 1936
This detail of a Jeanne Lanvin kimono-style evening jacket demonstrates the dramatic effect of finishing a garment with parallel lines of machine topstitching. Two lines run from the shoulders to the front edge to give an illusion of a separate collar.

Linings disguise construction, give body to a shape, and provide a luxurious feel to a garment. The choice of fabric can offer a contrast to the main garment and also display the designer's signature detail. In a haute couture garment, raw edges of seams are either hidden or finished by hand. Some hand stitching is a sign of quality and in tailoring is seen on lapels and pocket flaps. The finest quality silk scarves have a hand-rolled stitched hem. Japanese designers in Paris in the 1980s established deconstruction, showing garments that deliberately looked unfinished and had frayed edges.

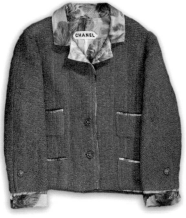

Contrasting lining, 1964
This Chanel jacket is made of the finest lilac mohair tweed and is contrasted with a floral printed silk that is used to create false cuffs and collar. The matching dress was lined in the same fabric, although this was hidden from view.

Deconstruction, 2001 (left)

Rei Kawakubo of Comme des Garçons has become known since the 1980s for her unconventional approach to clothing. She likes to surprise and challenge by using deconstruction. This dress illustrates that approach by seeming to be a half-finished outfit on a stand.

Fraying, 2010 (right)

Miuccia Prada's conceptual approach to the collection that this outfit is from explains why this coat with frayed edges looks unfinished. Her approach is an ironic take on transparency and vision in dealing with the past and the present.

Finishing, 1971 (above)

The sharp fashionable cut and the turquoise color of this Mr. Fish suit are complimented by the way it is finished. A silk binding in the same color is used down the center front of the jacket, around the collar, and on the pocket flaps.

Fastenings

Lacing, 1885
A moiré ball gown bodice, inspired by corsetry: the lacing that would usually be hidden is made a feature. The deep point and the bow emphasize the wearer's tiny waist.

Early forms of fastenings evolved from brooches and pins to laces, buttons, and hooks and eyes. Lacing, once merely practical, became decorative and suggestive, with references to corsets. Metal zippers, previously used on leather bags and sports jackets, were used on women's clothing in the 1930s. They were produced in lighter versions after the introduction of nylon. Today, large press studs can be seen in the collections of Burberry and Yamamoto.

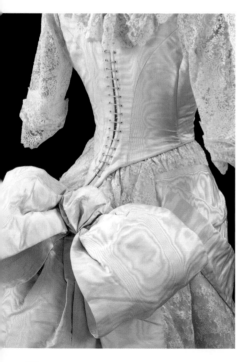

Fall front fastening, 1810–20
Breeches had a center front opening until about 1770, when it was replaced by the fall front, or flap, opening. Here, the deep waistband buttons together at the front, while the flap is attached to the lowest part with three horizontal buttons.

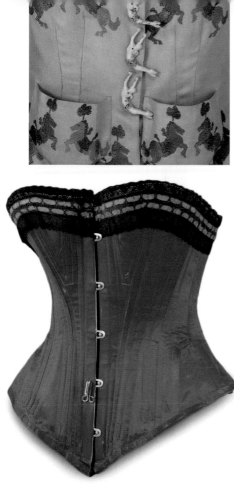

Buttons, 1938 (left)

Elsa Schiaparelli's jacket from her Circus collection reminds us that she considered every detail as an integral part of her theme. The fabric was commissioned for her, while the acrobat buttons were specially cast in metal.

Metal slot and stud fastening, 1890s

The metal slot and stud fastening at the front of this corset kept the front rigid, while laces were altered at the center back to fit the wearer. The petticoat would be attached to the hook at the waist to prevent it from riding up.

Zipper fastening, 1985

This Montana wool jersey dress has a cleverly constructed shape that, apart from its large rounded shoulders, relies on detail for its effect. The zipper is a practical fastening, but here, along with the welt seams, it is also part of the design.

MATERIALS

Materials

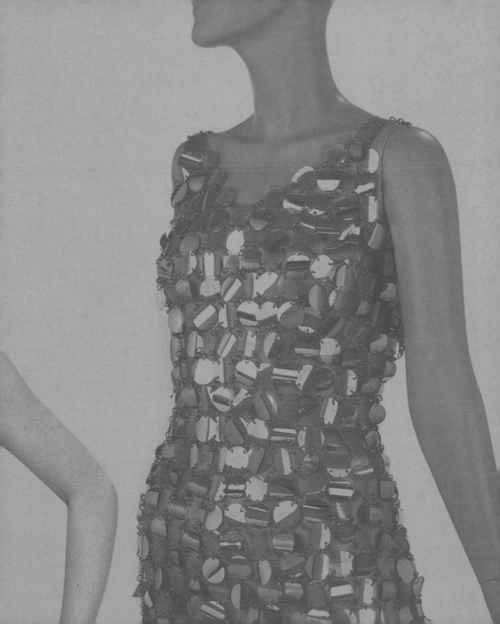

Introduction

Hand loom, 1747
This Hogarth print shows an apprentice seated at his hand loom. Weaving a complicated pattern was slow, and therefore, fabrics such as patterned silks, which were only eighteen inches wide, were expensive.

Materials can inspire design, or designers might work with a textile company to produce fabric to their specification and exclusivity. Fabrics have different qualities dictated by factors, such as the fiber of the cloth and the weave, finish, and decoration. Synthetic yarns were originally developed as a less expensive alternative to natural fibers. They had novelty value between the 1950s and 1970s, before the popularity of natural fibers was restored.

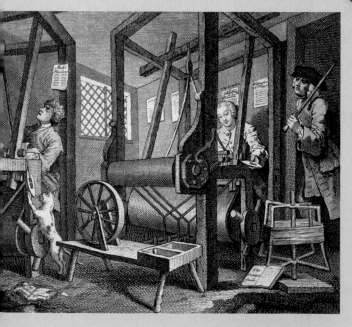

Shibori technique, 1950–60 (above)
This detail of the Japanese shibori tie-dyeing technique in dark blue, light blue, and white illustrates the kind of decoration that has been imitated in the West, particularly during the late 1960s and in the early 21st century.

Woven silks, 1760–64
This page from a Lyons salesman's book of woven silk samples illustrates the range of silks available in the 18th century. At the time, Lyons was acknowledged as the most important European center for woven silks.

Lace overdress, 1958 (below)
Balenciaga's Baby Doll outfit is a crepe-de-chine sheath dress with a voluminous black lace overdress. The sheer and decorative quality of the lace evokes a sense of lightness and youth.

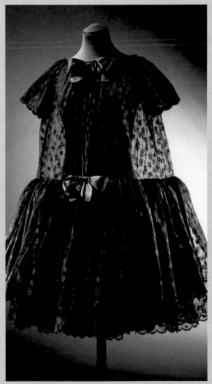

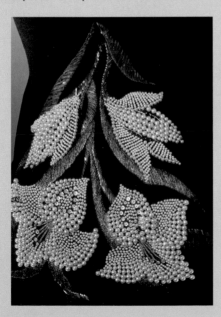

Decoration, 1939 (left)
Elsa Schiaparelli's short-sleeve evening dress is made of matte crepe and embroidered with a three-dimensional spray of lilies in pearls and gold threads.

Natural

Silk gazar, 1963
Balenciaga's evening cape is made of silk gazar manufactured by Abraham Ltd. Gazar is a fine, lightweight tightly woven fabric that is crisp and so holds a shape well, as here where the cape stands away from the body.

Historically, plant and animal sources have supplied fibers such as linen, wool, silk, and cotton. More recently, hemp, bamboo, and banana leaves have become popular. These different fibers have inherent qualities that can keep the wearer warm or cool, and their appearance varies, depending on the spin of the yarn and the weave. In the past, natural fibers were mixed together, while today they can be combined with synthetics for additional strength or elasticity.

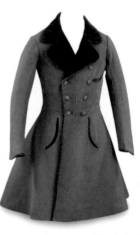

Wool, 1830s
Beaver cloth is a thick reversible, double cloth, where the surface is sheared to form a smooth, dense nap. It does not fray and its thickness makes it ideal for an overcoat such as this man's frock coat with a velvet collar.

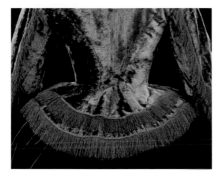

Silk plush, 1855 (above)
This luxurious winter fabric is a kind of velvet with a long soft nap that resembles fur. Its glossy texture contrasts well with the matte silk fringe trim along the bottom edge of this woman's promenade jacket.

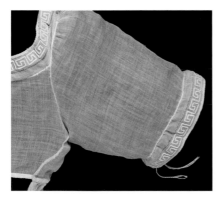

Cotton, ca. 1800 (above)
Fine white muslin was a luxury fabric in the early 19th century, when the finest quality was imported from India. This example has a Greek key pattern embroidered in white cotton thread.

Linen, ca. 1912 (below)
The sky blue linen of this day dress clearly shows the matte, slightly ribbed face of the fabric. It is an ideal summer cloth because it is lightweight and cool. The silk organza collar is used as a dramatic contrast in color and texture.

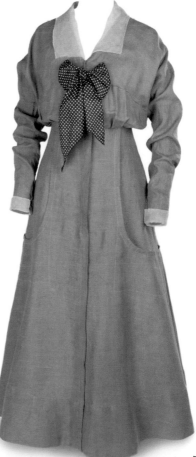

59

Man-Made & Synthetic

Plastic, 1967
Paco Rabanne had a reputation for being the most experimental of the designers in Paris in the 1960s. This dress of plastic disks joined together with metal wire reveals his background in architecture.

During the 20th century, alternatives to natural fibers were discovered. Rayon, produced from wood pulp, was created by Samuel Courtauld in 1904 as a cheap alternative to silk. It was used from the 1920s for stockings, lingerie, and other garments. DuPont manufactured the first polyamide yarn, nylon, in 1939; it became popular for stockings. Elastane fibers were manufactured in 1960 as spandex or Lycra®. Research continues into "smart fibers" that can react to body heat or even block ultraviolet rays.

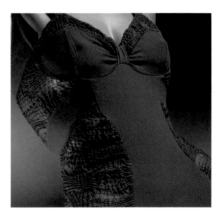

Lycra®, 1991 (above)
Elasticized fabrics, such as Lycra®, cling to and reveal the shape of the body. Val Piriou used Lycra® to create this sexy minidress with a plunging laced back and semitransparent lace panels.

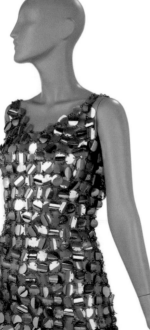

Rayon jersey, 1970s (left)

This luxurious Yuki dress shows that designers are happy to use synthetic material for its aesthetic quality. This knitted rayon jersey fabric has a rich color and gathers well to complement the halter neck design.

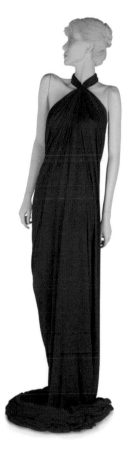

Synthetic lamé, 1981

Gold-and-silver synthetic lamé has been knife-pleated and formed into swirls as part of this Renaissance-inspired evening gown by Zandra Rhodes. The stiffness in the fabric combined with the pleating enables the dramatic shape to be formed. (See also The Ball Gown, pages 94–95.)

Vicose and lurex, 1996 (right)

Julien MacDonald created this evening outfit himself in three weeks using machine and hand-knitted black viscose and gold lurex bands. The inspiration was 1930s bias-cut gowns, but the materials are modern.

Weaves

Treadle looms, known in Europe since the Middle Ages, were worked using the hands and feet, but during the Industrial Revolution in the late 18th and early 19th centuries, this process was mechanized. In the 21st century, looms are linked to computers, but some companies, such as Prelle in Lyons, still produce silks by hand. Weaves create fabrics with different properties. The twill weave, which is often used for jeans, is strong, but the satin weave gives a lustrous surface to the cloth. Woven patterns can vary from simple stripes and checks to complicated florals.

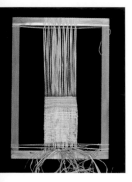

Warp and weft
This small hand loom, belonging to the artist Sue Lawty, demonstrates how the warp and weft threads interlace to form cloth.

Paisley
Cashmere shawls, made from goat's wool, have been popular accessories in the West since the late 18th century, and the design of a pinecone became known as Paisley after the town in Scotland began its own shawl production.

Brocade
Brocade is a weave for silk that has a pattern, usually floral (here shown on graph paper), made by wefts that only go the width of the motif and then are turned back. The background weave can be plain, twill, or satin. It has a stiff drape that holds a shape well.

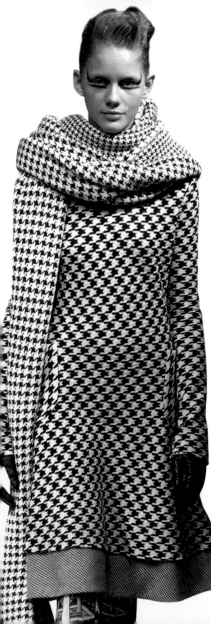

Satin (right)
This evening outfit from Chanel's haute couture summer 2010 collection demonstrates the shiny surface of a satin weave used for silks or synthetics. Satin produces a smooth and slippery finish on the right side but a dull reverse.

Houndstooth, 2003
Yamamoto's outfit uses a variety of houndstooth patterns. These are created by a twill weave combined with a particular order of coloring in the warp and weft threads, which are normally black and white.

63

Dyes

Natural dyes, 1949
Lady Howard-Johnston purchased this day dress from her regular designer, Jacques Fath, but unusually, wanted it to be made in her husband's tartan. She purchased the woollen fabric, which was handwoven and hand dyed, directly from Scotland.

Until the middle of the 19th century, all fabric dyes came from natural sources: animal, vegetable, and mineral. Mordants, such as salt and urine, were mixed with dyes to create different colors and produce a stable shade that was less likely to fade. Synthetic aniline dyes, which were produced from coal tar, were available in the 1850s, created by rival European chemists. These dyes provided bright intensive colors and significantly reduced production costs.

Synthetic purple, 1873
The vivid hue of this dress is within the range of colors discovered by Sir William Henry Perkins in 1856 while he was searching for a synthetic formula to replace quinine. This first synthetic dye was called aniline violet or mauveine.

Turkey red, ca. 1860
This printed cotton petticoat has a ground color made from the Turkey red dye. The bright color was produced by soaking a cloth, dyed with the madder plant, in oil and soda. Its name derives from its origins in the Near East.

Yellow silk, 1810
This silk dress from 1810 has a strong canary yellow color enhanced by the sheen of the silk, showing that natural dyes can produce deep colors. It contrasts with the puffs of ivory silk inspired by Renaissance styles.

Dip-dyeing, 2004 (below)
Prada shows the elements identified with its house style in this image—textile treatments and vintage. The outfit uses dip-dyeing, but instead of a Bohemian hippie style it is combined with elements of the prim 1950s.

Print

Screen printing, 1969

The large panels in this Zandra Rhodes felt coat provide an ideal canvas for the gradating screen-printed design. It was worn over a chiffon dress printed to match and demonstrated the designer's interest in both pattern and texture.

Printed cottons, using carved wooden blocks, were introduced from India and became fashionable in Europe in the 18th century. In 1783, the process was mechanized with engraved copper rollers that could reproduce fine and detailed images. The modern method of screen printing is a slow and expensive process, because a different screen is needed for each color. This means a complicated image is expensive and luxurious.

Printed wool, ca. 1855 (above)

The combination of a woven stripe and a printed small floral spray on this bodice of cream wool gauze was a popular fashion in the mid-19th century. The pleating at the front adds another dimension to both of the patterns.

Mixed patterns, 2008 (below)
Dries van Noten has a reputation for mixing patterns and colors on fine silks to produce luxurious day wear. He prints several different patterns on one piece, a technique that can be seen on the outfit here.

Printed silk, 1960 (above)
Inspired by medieval banners, Emilio Pucci created colorful printed silk designs that were applied to everything from pants and dresses to ties. In doing so, he also created a signature style that the fashion house continues to reference.

Toile de Jouy, 1792 (above)
The name for this style of mono-printing derives from the place, Jouy, near Paris, where Oberkampf started a cotton print works in 1759. The artist Huet, who designed this figurative piece, was one of his designers. Today, the designs evoke 18th-century French style.

Decoration

Applied decoration on a garment was traditionally associated with haute couture, but in recent times, as materials and labor costs have fallen, decoration is also found on less expensive clothing. The techniques vary from applying stitches of colored and metal threads to the use of beads, sequins, and feathers, but adding these effects requires skill and time. In the West, decoration on men's garments has declined, except for ceremonial or theatrical use.

Stephane Rolland, 2010
Rolland has built a reputation for red carpet glamour, and for his haute couture summer 2010 collection, he collaborated with a chemist in order to produce a gold lacquered paint that could be applied to fabric. It was used dramatically on otherwise unadorned evening wear.

Sequins, 1932

Chanel's evening dress is covered in sequins and has a trompe l'œil bow effect over the front bodice. The loops of the bow are indicated by the sequined design, but the hanging ribbons are three-dimensional. (See The Red Carpet Gown, pages 96–97.)

Beading, 1957

The beading on this state gown designed by Norman Hartnell includes Napoleon's personal emblem, the bee, made of gold twisted thread with iridescent pearl wings and beaded antennae. The dress is also covered in gold beads, brilliants, and pearls. (See The Ball Gown, pages 94–95.)

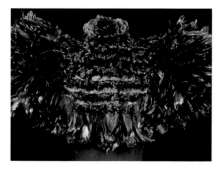

Feathers, 1895

This short evening cape, designed by Champot of Paris, is entirely covered by bunches of black and green cock feathers, some of which have been curled. They are mounted onto a cotton base and the cape has been lined with black silk satin.

Court dress embroidery, 1800

Court dress required the most elaborate form of clothing and was an important source of work for embroiderers. The motifs stitched here in metal threads would have been worked on the cloth before it was made into a coat.

Lace

By the 16th century, needle and bobbin handmade lace was used as a trimming. Countries such as France, Belgium, and Italy were associated with work of fine quality. Machine-made lace was produced in the 1840s, and this is the type of lace mainly seen today for whole garments. Lace has also acquired cultural meanings, such as white for purity, red for scandal, and black for mourning or drama.

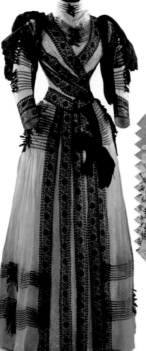

Blonde lace, 1820
So-called blonde lace, made from natural-colored silk thread, was a luxurious trimming that was ideal for an evening dress. Its slight luster combined with fine fabrics and metal embroidery would have gleamed in the candlelight used at the time. (See also The Ball Gown, pages 94–95.)

Black lace, 1889 (left)
The dramatic effect of this dress is mainly due to the color theme of black and ivory. However, the use of strips of transparent black lace lightens its appearance and softens the overall impression.

White lace, ca. 1904
White summer dresses from around 1900 often display decorative contrasting textures. This example shows a combination of handmade lace, pin-tucked cotton lawn, and crocheted flowers.

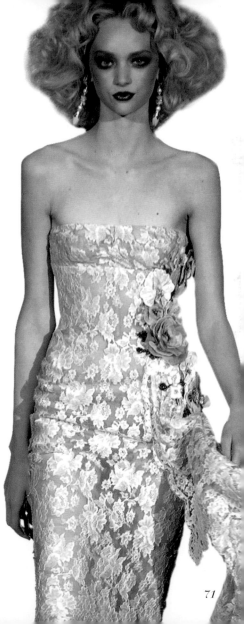

Valentino, 2004 (right)

Valentino has a reputation for creating clothes in luxurious fabrics that exude elegant femininity. However, the transparent pale pink lace dress seen here was a sexier creation that drew its inspiration from romantic lingerie.

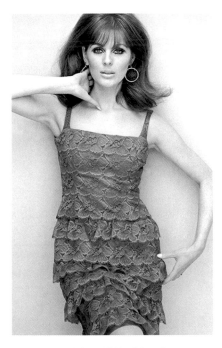

Broderie anglaise, 1960s (above)

The technique of producing a lace effect on woven cotton by creating petal shapes with eyelet holes overcast with padded satin stitch, was popular in the 19th century and was revived in the 1960s, partly as a reaction to the introduction of synthetic fabrics.

Male Formal

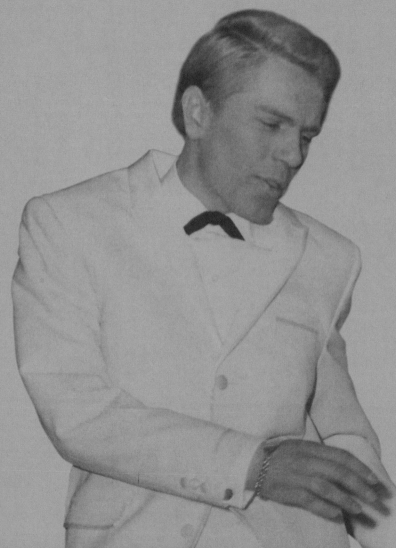

Introduction

Since the 17th century, men's formal dress has been established as essentially three pieces: the coat, the vest, and breeches or pants. During the 19th century, variation of dress for different activities increased. Codes for "correct" dressing were established, often by members of royalty and celebrities. Since the 1950s, occasions for formal dress have become less frequent for men, but they still include presidential dinners, royal garden parties, balls, red carpet events, and weddings.

Modern tailoring, 1996 (above)
Oswald Boateng opened his business selling "bespoke," or custom-made, close to Savile Row, London, in 1995. This wool and mohair single-breasted suit has a slim silhouette and bright color that offers a youthful approach to traditional tailoring.

Evening dress, 1821
This satirical illustration shows a ball at the exclusive London club Almacks, where knee breeches and not pants had to be worn. The men are dressed in tailed evening coats, mainly in black or blue, with breeches, stockings, and pumps.

Pants, 2006 (right)

The Belgian designer Raf Simons has a reputation as an innovative menswear designer for a young generation. These voluminous high-waist pants in muted gray show his preference for strong shapes, whether skinny or baggy.

Modern tailcoat, 2006 (below)

This Dior Homme outfit is a provocative version of the traditional tailcoat worn for only the most formal occasions. In its deconstructed form, for summer wear, it lacks sleeves and all the other expected items, such as a shirt, vest, and tie.

Day suit, 1950s

This photograph by Cecil Beaton demonstrates the particularly English upper-class style that the Duke of Windsor was admired for. He preferred a double-breasted flannel suit for town wear, worn with the shirt cuff displayed, plus handkerchief and carnation.

Weddings

Fashionable, 1937
For the Duke of
Windsor's wedding,
held in a French
château, he dressed
in the traditional
black cutaway coat
with a dark yellow
vest, a white fold-
down collared
shirt, and a gray
checkered tie. In his
buttonhole, he wore
a white carnation.

Clothing for weddings often refers back to earlier, sartorial codes of the late 19th century, when the frock coat and tailed cutaway suit were part of full dress worn for the most formal business and social occasions. The cutaway coat has become the most popular style for modern weddings: it is normally black or gray in color, with lapels faced with satin or grosgrain. An individual touch is provided by the type and color of necktie and vest.

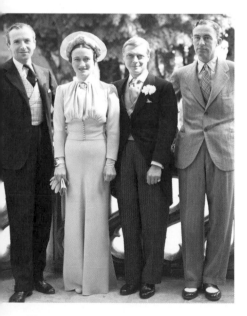

**Conventional,
1910 (right)**
In the early 1900s,
this type of black
cutaway suit was
worn as everyday
dress by business
and professional
gentlemen. This
example is made
of wool edged with
silk braid, and was
also worn at a
family wedding.

Modern, 1960 (below)

This wedding photograph of Princess Margaret and Anthony Armstrong-Jones shows how little the formal dress code for men had changed since 1910 (see opposite). Modern signs are the softer fold-down collar and simple, pale cravat.

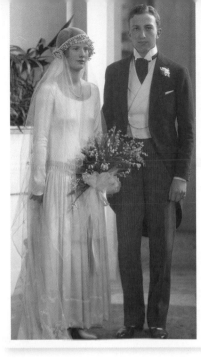

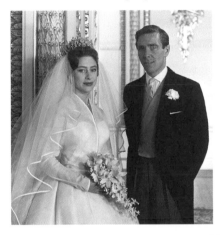

Moss Bros, 1996

This gray wool cutaway suit has distinctive sloping fronts that derive from riding coats of the late 18th century, known by 1850 as "the cutaway." It remains a style often worn for modern weddings with paler silk accessories.

Traditional, 1926 (above)

The upper-class English gentleman in this photograph wears a cutaway suit with the jacket worn open to display the pale double-breasted silk vest and the traditional watch chain. He has the very formal starched wing collar and cravat.

The Evening/Dinner Jacket

White tuxedo, 1960
This white tuxedo, which is worn by the singer Adam Faith, is matched with white, not black, pants. They have the distinctive silk braid trimming of evening pants down the seams.

Changes in evening wear reflect a more casual approach to dress and the desire for comfort from the middle of the 19th century. The black tailcoat, normally worn with pants in place of breeches, had become the norm. The dinner jacket was worn as a version of the lounge jacket from about 1850 and was given the American name tuxedo in 1886. By the 1950s, it was the most popular evening wear, mainly in black or cream.

Henry Poole, 1996
Poole was the first tailor to make a dinner suit with a short jacket. In the mid-19th century, the Prince of Wales asked him to create a black version of the lounge coat, which he wore for informal dinner parties.

Nehru jacket, 1988 (left)

The standing collar style worn by Prime Minister Nehru was made popular in the West by Pierre Cardin in the 1960s after he visited India. When Scott Crolla created this gold-and-black version in 1988, the ornate fabric was against the trend for plain black.

Yves Saint Laurent, 2007 (left)

Stefano Pilati created this black dinner suit, with the traditional elements of a jacket with silk-faced lapels and a collar-attached dress shirt that is fastened by fancy studs. However, the pants are fashionably short, displaying a silk-clad ankle.

Tailcoat, 1923 (right)

Here is an example of full evening dress consisting of tailcoat and pants with a matching vest, wing collar, and white tie as immortalized by Fred Astaire. Minor changes in fashion affected the cut of the pants and lapel width.

The Smoking Jacket

Historically, men have dressed more colorfully and comfortably when in private, and during the 19th century, the smoking jacket was considered the fashionable garment to wear at home. The name derives from the habit of smoking strong tobacco, which became popular after the 1850s. It was a short, easy-fitting jacket made of soft, rich materials, often decorated with quilting and cording. It was worn with day or evening pants and a cap.

Charles Dickens, 1859

Dickens wears the 19th-century plain version of the smoking jacket that was typically made from a soft comfortable fabric, such as velvet. The only decoration is in the deep cuff to the sleeves, which have been faced in a rich contrasting silk.

Bottega Veneta, 2010

This red silk jacket is made from the kind of luxurious fabric that this label is known for, and illustrates its collection's Teddy Boy theme by combining the smoking jacket with a string tie and white socks.

Paul Smith, 2002 (below)

Paul Smith's velvet jacket has a hand-painted flower covering the pocket on one side. This is a reference to the smoking jackets of the late 19th century, which could be decorated with hand-embroidered flowers or birds.

Smoking suit, 1906

In this example, the double-breasted smoking jacket is part of a suit with loose pajama-style pants made from Indian lightweight handkerchief silk. Comfort, luxury, and flamboyance are key elements.

Mr. Fish, 1970

This synthetic Lurex jacket was directly inspired by the more flamboyant of the 19th-century's smoking jackets. Art nouveau–style fabric design has been combined with corded silk fastenings and jet beaded tassels.

City Suits

City suit, 1930s
This woolen, double-breasted, four-buttoned, pin-striped suit by Radford Jones clearly shows the fashionable shape for men's tailoring during the 1930s. The ideal, powerful masculine triangle is created with broad, padded shoulders and wide lapels.

The business suit, whether mass produced or individually tailored, has been associated with city wear since the 1950s. Its roots, however, go back to the 19th century, when Savile Row in London became the leading provider of custom-made and made-to-measure menswear. Today, each house continues tailoring traditions while adding its own style in linings or numbers of cuff buttons. Fashion leaders, from Edward VII to Hedi Slimane, have had an impact on different details, from the shape, color, and pattern to the way they are worn.

Summer suit, 2009
This Paul Smith suit has many traditional references. The fabric echoes the pale summer suits of the 1900s and is a reverse of the 1950s navy pinstripe. The traditional soft tailoring of the jacket shows 1960s narrow-notched lapels; the hipsters are a casual version of 1900s cuffs.

Pin-striped suit, 1970s

Traditional norms are subverted in this suit made by John Stephens for the milliner David Shilling. The woolen fabric has an exaggeratedly wide stripe and the jacket is very tight-fitting with extremely large patch pockets. The suit pants have the baggy, wide flares only associated with youth fashion in the 1970s.

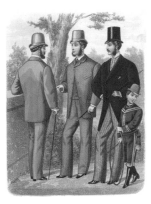

Lounge suit, 1876 (above)

The two figures on the left sport the lounge suit of matching jacket, vest, and pants. Only the top jacket button was fastened. Pants were straight cut and held up by suspenders.

Brown suit, 1960s

This Tommy Nutter woolen suit jacket was made in Savile Row in 1969. The fabric is gray with loud, reddish brown stripes, but the wide lapel and breast pocket, where stripes seamlessly match, show the traditional tailoring for which Nutter was renowned. His clients included The Beatles and Mick Jagger.

The Blazer

Sporting wear, 1873

This English fashion plate shows the man on the left wearing a typical single-breasted loosely shaped blazer of the time with patch pockets and cuff buttons. The soft, folded collar of the shirt, white pants, and straw boater complete the style.

The double- or single-breasted navy blazer has come to represent a typically British style. Originally, this was a dark blue jacket fastened with metal buttons, which was worn aboard HMS *Blazer* in the 1860s. By the 1920s, this had become a fashionable form of dress, teamed with contrasting white flannel pants and topped with a straw boater for seaside and boating. Variations, identifying group membership, include regimental buttons, badges, and colored stripes.

Leander, 1995

Since the 1880s, it has been fashionable to team a dark blazer with white flannel pants. Here, the outfit has been adapted to represent membership of the Leander Club, an English rowing club, by adding a pink tie and a pink hatband.

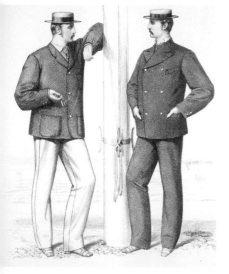

Yves Saint Laurent, 2010
Stefano Pilati's version of
the blazer explores the
college preppy style for
winter. A three-quarter
length sleeve from
1950s womenswear
is combined with a
broad-shouldered,
boxy-shaped jacket
worn with full
draped pants.

**Tommy Hilfiger, 2008
(below)**
Traditional blazer references
are here in the double-
breasted cut and six metal
buttons of this jacket.
The shoulder epaulets with
the striped pants and top
emphasize the naval history
and the stripes suggest
summer fashion.

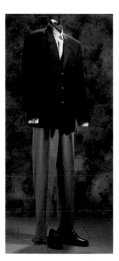

Paul Smith, 1995 (above)
This blazer is made of navy
wool with gilt buttons, but it
is less sharply tailored than
the conventional jacket.
Because it is single-breasted
with only three buttons,
the overall effect is preppy
instead of military.

Pants

Pantaloons, 1814
This French fashion plate shows a man wearing tight-fitting pants, called pantaloons, which were introduced in the 1790s. They could be made of machine-knitted cotton that allowed a close fit and were kept in place by button fastenings or straps.

In the late 18th century, pants were only worn by the working classes; by the early 19th century, however, they began to replace knee breeches in fashionable dress. Initially, they were worn for day wear, but later also for evening and ceremonial occasions when the Duke of Wellington (1769–1852) promoted their adoption. The main variations since then have been connected to whether they reveal or conceal the legs and whether suspenders or belts are used for support.

Bags, 1923
Fred Astaire is wearing fashionably wide cut pants with cuffs. Around this time male students at Oxford University started wearing wide-leg pants measuring up to twenty-four inches, and these became known as Oxford Bags.

Flares, 1968 (right)
These low-cut, flared pants
designed by Mr. Fish in the
1960s were called hipsters.
The lack of a central crease
references pants of the 1870s.
Here the soft pajama style is
combined with a military-
inspired jacket.

Skinny cut, 2006 (right)
Hedi Slimane, while a
designer at Dior Homme,
promoted the skinny-leg
look. Here, the pants, worn
with suspenders, reflect
the collection's 1960s
theme of London mods
and skinheads.

Cossack pants, 1820s
These pants took their
name from the Cossack
soldiers of Czar Alexander
I, who visited London in
1814. The cut of the
fabric is wide over the
hip, gathered into a band
at the waist, and then
narrow at the foot.

Female Formal

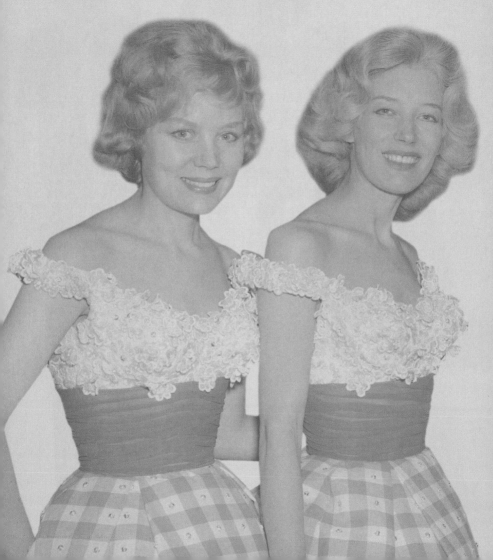

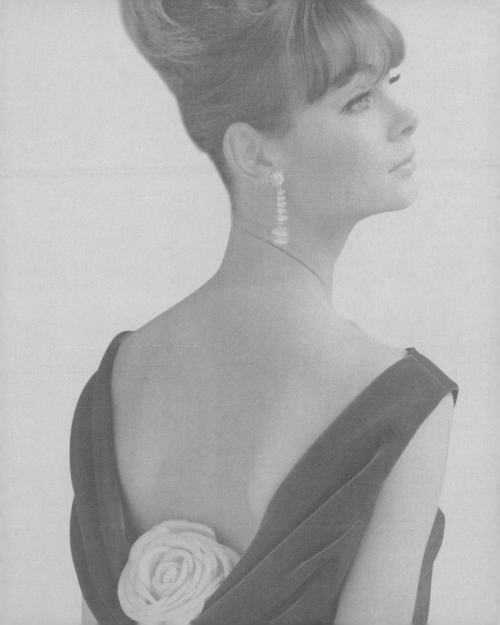

Introduction

Princess Margaret, 1960

Princess Margaret's wedding dress became a model for other brides during the 1960s. Norman Hartnell created the dress, its skirt using forty yards of silk organza over stiff petticoats. The lack of decoration focused attention on the diamond tiara.

In the 19th century, the most formal occasions that required elaborate dress involved royalty and court occasions. During the early decades of the 20th century, women's roles were changing socially, economically, and politically, and their dress changed accordingly. By the 1950s in Britain, debutantes were no longer presented officially, and the need for grand clothing was more linked to evening wear and bridal wear. As women's lives became more active and equal to men's, there were opportunities to travel and take part in business where new items of clothing were required. Inspiration was taken from menswear, the military, and historical dress.

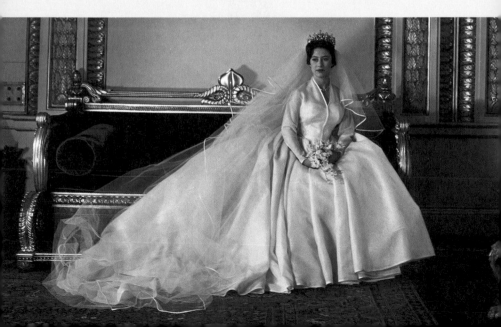

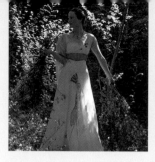

Duchess of Windsor, 1937
This silk organza dress with a lobster design was bought from its designer Elsa Schiaparelli as part of the Duchess's wedding trousseau. It was an evening gown produced with the surrealist artist Dalí, who was associated with the lobster motif.

Lanvin, 1955
Jean Demarchy's illustration of a Lanvin evening gown shows the romantic, historical, full-skirt style that is a contrast to the sleeveless boned bodice. The flowers and drapes may be a reference to Lanvin's 18th-century-inspired gowns of the 1920s.

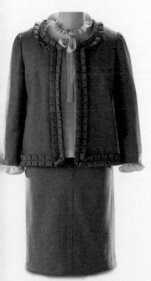

Tutti Frutti, 1962
Mary Quant designed this suit for the modern woman, who needed practical but stylish work clothes. The use of flannel, a conventional suiting fabric, is given a different look with the pie-crust trimming that sparked a trend for ruffled suits.

Camille Clifford, 1904 (left)
This evening dress demonstrates how the use of a single dark color can both emphasize the shape of a gown and offer a contrast to the color of unadorned flesh.

Weddings

Emmanuel, 1979
This dress, which was inspired by the 1860s paintings of Winterhalter, is made of ivory silk taffeta and trimmed with pink bows and fabric flowers. It is very like the wedding dress that was designed for Princess Diana in 1981, which prompted many similar styles.

The custom for brides to wear white increased in the 19th century, particularly after Queen Victoria's wedding in 1840. Older brides, widows, and the less wealthy would wear their best dress, which more easily allowed them to follow the tradition of wearing the outfit after the wedding. The 19th-century gown followed current fashion; today, because a long dress is no longer the norm, brides often adopt an historical style.

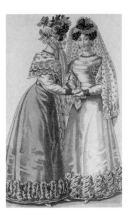

White wedding dress, 1825
A white dress had become much more popular by the 1820s. This French dress with its slightly high waist and A-line skirt, decorated around the hem, follows the fashion of the time.

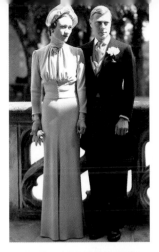

Duchess of Windsor, 1937
For her wedding, Wallis Simpson wore a pale Windsor Blue crepe dress with matching hat and gloves, designed by Mainbocher. The elegance of the dress and the slender frame of the bride is emphasized by the central folds and drape of the fabric.

Honiton lace, 1865 (right)
Queen Victoria's wedding dress was trimmed with Honiton lace and the style was still popular twenty-five years after the Queen's wedding, as seen in this bridal dress. Here, however, the skirt is worn over a large 1860s crinoline. (See also Wedding Boots on page 191.)

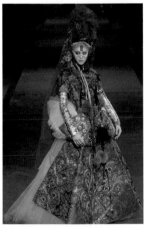

Christian Lacroix, 2002
Lacroix's richly embellished red bridal gown mixes references to create a fantasy alternative to the white dress. Indian and Spanish elements adorn the linear design.

The Ball Gown

Norman Hartnell, 1957
Hartnell designed this lavishly embroidered satin evening gown for Queen Elizabeth. The shape was inspired by dresses of the 1860s and it was decorated with French motifs because it was worn for a state visit to Paris. (See also Decoration, pages 68–69.)

A grand event, such as a formal dinner or ball, has always afforded women the opportunity to display an elegant, richly decorated gown. Since the 1950s, the shape of this type of evening dress has often been based on the curvaceous style of the mid-19th century. The gown is full length, has a full skirt, and is of luxurious fabric, cut low across the bosom to allow the display of fine jewelry.

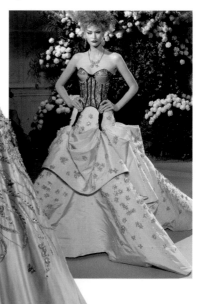

Christian Dior, 2010
John Galliano's haute couture pink-and-black gown encapsulates the trend for underwear to become outerwear. The voluminous skirt is inspired by the styles of the 1950s.

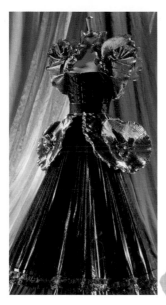

Zandra Rhodes, 1981

This black-and-gold gown, with a corset-style bodice, was inspired by the shape of Elizabethan dress and 18th-century panniers. This form is accentuated by the lamé fabric and use of pleats. (See also Man-Made and Synthetic, pages 60–61.)

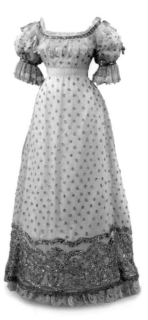

Maison Laferrèrc, 1900

Princess Alexandra of Denmark's Paris gown has a boned satin bodice and a gored skirt of seven panels. The train and the padded hem extend the elegant line and it is lavishly decorated with pearls, diamantes, and spangles. This famous French fashion house supplied the European aristocracy.

Ball dress, 1820 (above)

Ball dresses of the early 19th century were often constructed with two layers to create an effect of transparency. This overdress of machine-made silk bobbin net is decorated with metal strip embroidery and trimmed with blonde lace. (See also Lace, page 70.)

The Red Carpet Gown

A red carpet gown is designed to have a powerful impact on the viewer: it has the wow factor. Traditionally, members of royalty and show business celebrities have often been admired as fashion leaders. Events, such as the Academy Awards, offer an opportunity for designers to showcase their talents, particularly from the luxurious haute couture collection, on a famous client for maximum media coverage. If the outfit is approved, the client acquires a reputation for stylish dressing.

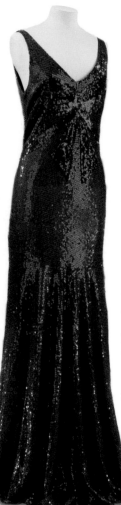

Chanel, 1932 (left)
This glamorous dress is made from a base of saxe blue silk completely covered in sequins of the same vibrant color. It has a low V-neck bodice and there is an even deeper V at the back, which dips to the waist to make a strong impact. (See also Decoration, pages 68–69.)

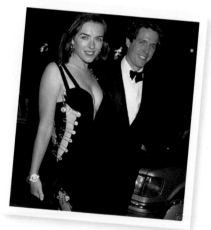

Versace, 1994
One of the most famous red carpet dress is the one worn by Elizabeth Hurley, which is said to have launched her modeling career. Inspired by punk, the revealing dress appears to be held together by safety pins, masking Versace's clever construction.

FEMALE FORMAL

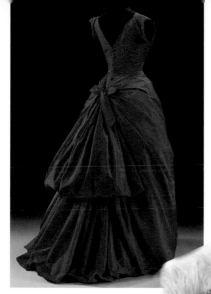

Rolland's style was inspired
by the glamorous 1980s soap
Dynasty and architecture.
This black Lurex haute
couture gown, with its
ruched, fitted shape
and dramatic train,
was bought by
Cheryl Cole to wear
on *The X Factor UK*
television show.

Balenciaga, 1955
The back of this dress, with
its V neckline and bustle style
shape, is the main focus of the
design. Its sculptural form has
been created with draped fabric
and a large, wired triangular
loop finished with a bow.

Balmain, 1950s
Balmain's luxurious dress
is thought to have been
worn to a court ball. The
decoration illustrates
the detailed handwork
carried out by different
speciality ateliers in
Paris: Lesage for the
embroidery and
Lemarié for
the feathers.

The Black Dress

The use of black in women's clothing has a complex history. When seen as an absence of color it has been used for mourning, particularly in the 19th century. Black has also been used for dramatic effect when combined with a contrasting color or textures, such as lace and beading. In the 1920s, designers, such as Chanel, promoted the idea of the simple short black dress that was suitable for all occasions, including the new cocktail hour.

Lanvin, 2010 (left)

Alber Elbaz has combined the kind of drapery associated with the neoclassical style and a 1980s Gothic glamour to create this asymmetrical dress. The soft supple leather creates strong folds that reflect the light to produce tones of black.

Thierry Mugler, 1999 (right)

Mugler has created an evening gown with a strong sculptural shape, and the black color strengthens this silhouette. The low neckline is emphasized by the addition of large beads, like stalagmites, that create a spiky Gothic effect.

Evening dress, 1894

This silk velvet dress has the very large sleeves that were high fashion in the 1890s with beads, sequins, and tulle creating texture. The dress was sold through a New York department store but was probably copied from a Paris model.

Jean Shrimpton, 1960s

Simple, form-fitting black dresses were popularized in the early 1960s by movies such as *Breakfast At Tiffany's*, with clothes designed by Givenchy for Audrey Hepburn. The low back drape of this example is emphasized by the white flower.

Mourning dress, 1817

This is a black evening dress suitable to be worn as part of the court mourning for Princess Charlotte, the only child of George IV. The style follows the fashion for a very high waistline and applied decoration that gives texture to the black fabric.

The Suit

Linen suit, 1894
Jacques Doucet had a reputation for producing elaborate evening gowns as well as more practical garments, such as suits for day wear. The jacket of this linen suit has wide masculine lapels combined with leg-of-mutton sleeves.

The popularity of the suit, consisting of a short jacket and skirt, derives from women's riding dress, which, in turn, was based on men's dress. This was seen as a more practical form of dress for walking as well as riding and, from around 1890, reflected a more active lifestyle for women.

As women began to take a more prominent role in the business world, this outfit became an essential part of the working woman's wardrobe.

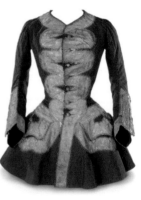

Riding jacket, 1750–59
These jackets were cut to combine a fitted shape that flattered a woman's figure with masculine references. These include the cut of the sleeve with a broad cuff and the large pockets covered with silver braid.

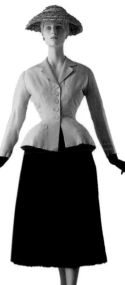

New Look, 1947 (right)

Carmel Snow of *Harper's Bazaar* called Dior's first collection the "New Look," and this suit has remained its most famous outfit. It was shocking after wartime rationing and knee-length straight skirts to see the long, full, pleated skirt and corseted jacket shape.

Khaki casual suit, 2009 (left)

Antonio Marras at Kenzo has created a romantic khaki suit inspired by Russian history. The masculine uniform is given a feminine shape by focusing attention on the waist with a wide belt, and the sleeves have bands of fur instead of cuffs.

Power suit, 1986

Edina Ronay's business suit references riding jackets, with details such as velvet pockets and collar lapels, and men's tailoring in the cut. The skirt is short and narrow, which draws the eye to the padded shoulders.

The Skirt

Beverley Sisters, 1959

Here, the Beverley Sisters (pictured with Nat King Cole) all wear the fashionable skirt of the late 1950s, a large puffball shape, which is worn with a wide sash to emphasize the waist. Checkered fabrics were popularized when Brigitte Bardot married in pink gingham in 1959.

In the second half of the 20th century, separates have dominated youth fashion, but skirts in high fashion have been mainly associated with suits for day or evening. The length and shape of skirts varied according to strict fashion trends up to the 1970s, but since that decade no rules have applied.

Louis Vuitton, 2010

Marc Jacobs was inspired by the extremely feminine shape of the 1950s that emphasized the bust and waist, and, in particular, by Brigitte Bardot. Here, a full summer gingham skirt has been transformed into winter plaid.

Yves Saint Laurent, 1976
The summer collection for 1976 was inspired by the Ballets Russes sets and costumes from the 1910s. Saint Laurent shows a lavish use of contrasting black and orange silks, trimmed with gold, in what appears to be two skirts.

Burberry Prorsum, 2010 (below)
Despite this narrow, short skirt, an opulent impression is created here by the use of neoclassical style draping. This tulip-shape chiffon mini is called the loop knot skirt and the styling echoes that of the jacket.

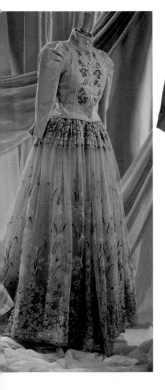

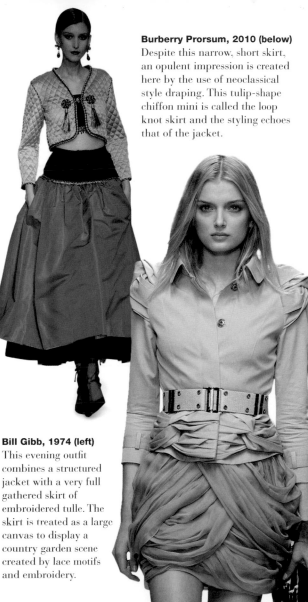

Bill Gibb, 1974 (left)
This evening outfit combines a structured jacket with a very full gathered skirt of embroidered tulle. The skirt is treated as a large canvas to display a country garden scene created by lace motifs and embroidery.

Pantsuits

Sarah Bernhardt, 1872
This internationally famous French actress starred in eighteen roles wearing pants, including *Hamlet*. She was a supporter of the wearing of pants by women although it was illegal in France. Here, she is wearing a fitted, if untailored, version of a pantsuit.

It took a long time for the formal pantsuit to become an accepted part of a woman's wardrobe. Certain women in political or aesthetic circles in the United States and Europe wore this form of dress in the 19th century. However, it was not until the success of Yves Saint Laurent's evening suit based on a man's dinner jacket and pants in 1966 that pants started to become acceptable evening dress for women.

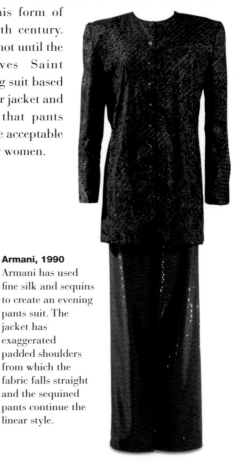

Armani, 1990
Armani has used fine silk and sequins to create an evening pants suit. The jacket has exaggerated padded shoulders from which the fabric falls straight and the sequined pants continue the linear style.

Antony Price, 1977 (right)
In the 1970s, Price built a reputation designing glamorous clothes for men and women, including the band Roxy Music. This dinner suit is based on the man's version but fitted at the waist and worn without a shirt.

Le Smoking, 2002 (right)
Yves Saint Laurent first showed his dinner suit in 1966, and since then it has been a signature outfit for the label. He wanted to create a practical wardrobe for women based on the basic pieces that were available to men.

Betsey Johnson, 2001 (left)
New York designer Betsey Johnson is known for her original extrovert style that includes fitted clothes in bright colors. The velvet pantsuit shown here combines a jacket fitted to the waist with tight 18th-century style breeches.

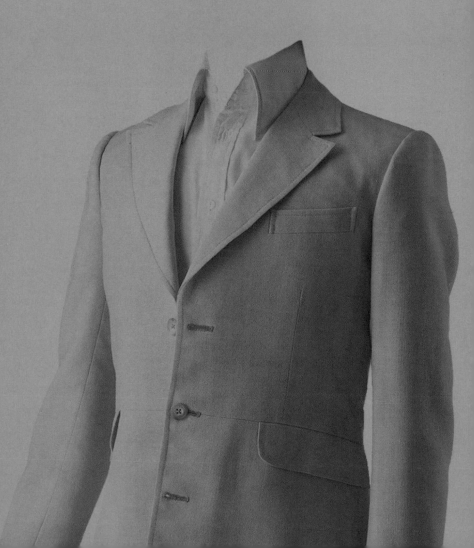

Male Casual

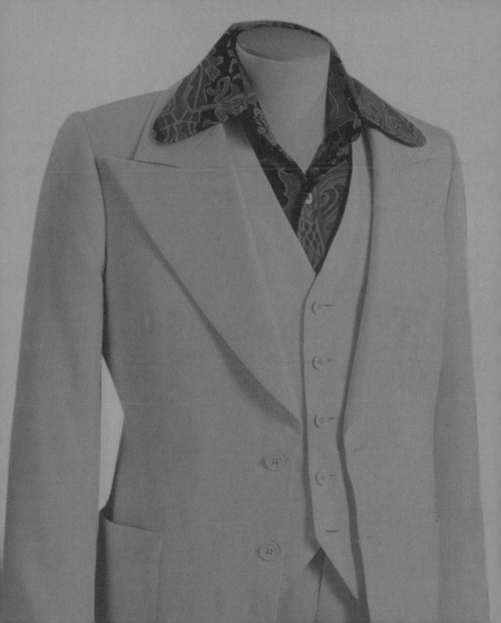

Introduction

Leather shirt, 2010
Leather shirts worn for summer show how changes in clothing can be linked to developments in materials. In the last few years leather, like this D&G example, has been produced in a lighter and softer form.

Men's clothing has been less affected by trends than womenswear and developments tend toward more comfortable, less restrictive, and lightweight clothing. This has marked the shift from the tailor to the designer. Since the 1970s, designers have been aware of the traditional codes of menswear but have interpreted them in a more innovative way. This has led to a wide choice of garments that reflect masculine identity from the country gentleman to the leather-clad rebel.

Trench coat, 2006 (right)
The trench coat has become popular worldwide, and designers are constantly inspired to rework the traditional style. In this example, the coat has been scaled down to a three-quarter length jacket that is cut to Dior's minimal, skinny silhouette.

Leather look, 1970s

This brown leather outfit of cap, vest, pants and platform shoes represents the Soul Boy style worn in the United States and Great Britain in the early 1970s and popularized by musicians such as Errol Brown and Isaac Hayes.

Casual pants, 1985

In 1980, Giorgio Armani designed the wardrobe for Richard Gere's elegantly dressed character in *American Gigolo*. These pants, made of a fine wool and silk blend, reflect this casual, expensive style.

Checkered shirt, 1957

Jim Dale had a rock 'n' roll hit single in 1957, and here he wears the checkered shirt and casual pants that he performed in. The shirt, worn without a tie, derives from American work wear and cowboy style.

The Trench Coat

Humphrey Bogart, 1943

When Humphrey Bogart wore a trench coat in *Casablanca*, it helped to popularize the style, giving it a business instead of a military look. The trench, tied, not buckled, and worn with a fedora hat, had attitude.

The name was given to this coat by soldiers in the trenches during World War I after Thomas Burberry's new design for an officer's raincoat was accepted by the UK War Office. It was made from the new waterproof gabardine that Burberry had also developed, and featured a back yoke, buckled cuff straps, epaulets, a storm flap on one shoulder, and storm pockets.

Paul Smith, 2010

This bright red trench coat, worn with pants and shoes of the same color, subverts the convention of military camouflage. The fabric is also contrary: instead of being a practical waterproof cotton or wool, it is silk.

Raf Simons, 2010 (right)
Simons has produced a
trench coat that uses the
traditional color and fabric
but experiments with the
cut. Starting with the back
yoke and storm flap
and developing the
horizontal lines, he has
created what appears to
be three garments.

Hermès, 2010 (below)
This version of the trench coat
follows the summer trend for
soft leather and also relates to
the history of Hermès and its
production of saddles and
leather goods. The abundant
use of leather here and the
taupe color evoke luxury.

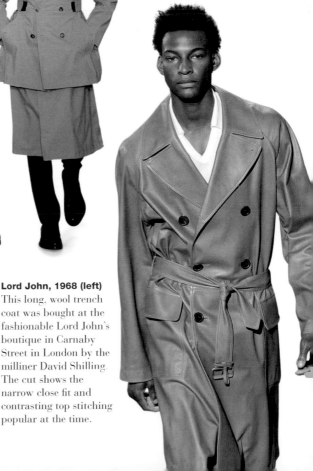

Lord John, 1968 (left)
This long, wool trench
coat was bought at the
fashionable Lord John's
boutique in Carnaby
Street in London by the
milliner David Shilling.
The cut shows the
narrow close fit and
contrasting top stitching
popular at the time.

The White Suit

Pale suits have been popular since the late 19th century, and as the fashionable cut of pants and jackets altered, these same changes were also reflected in the design of suits. Their enduring popularity attests to menswear becoming less formal as lighter colors and fabrics associated with sailing and other sports were worn in an urban context. Into the 20th century, etiquette relaxed even more, allowing pale colors to become acceptable as evening wear.

French fashion plate, 1920s
Suits of the 1910s and early 1920s were cut on slim lines with a soft shoulder line and narrow pants. This pale suit is worn with a black tie and spats over the shoes, creating the impression of city wear.

Versace, 2010
Versace's summer suit features various white fabrics and combines traditional formal tailoring with a modern layered look. The double-breasted jacket has sharp, notched lapels and buckles instead of buttons.

Flannel suit, 1904 (left)
This flannel suit with mother-of-pearl buttons is an example of the type of light-colored suits that were fashionable summer wear in the 1890s. The double-breasted jacket was derived from the Reefer coat worn for sailing.

Regency suit, 1972 (right)
This linen suit from Blades was called "Regency" because of the shape of the jacket. The waist seam is similar to those seen on early 19th-century coats but the flared hipsters were a 1970s trend.

Tommy Nutter, 1973 (above)
In 1977, the movie *Saturday Night Fever* starred John Travolta as the disco king in his white three-piece suit and black open-neck shirt. Pale tailored suits worn without a tie became popular as casual evening wear.

Jackets

Perfecto jacket
Irving Schott
designed his first
motorcycle jacket in
1928 and named it
the Perfecto after
his favorite cigar.
When the jacket,
with its angled
zipper pocket, was
worn by Marlon
Brando, it became
a classic rebel
garment.

The rise in popularity of the casual jacket in the second half of the 20th century reflected a move away from formal dressing. After World War II, a range of jackets emerged that borrowed details from the military and reflected a younger, more active lifestyle. These jackets were more about expressing personal or group identity, and in modern times they have become part of the vocabulary of styles for designers to experiment with.

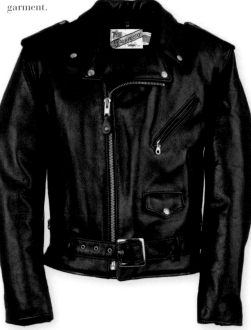

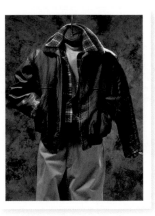

Aviator jacket, 1950s
The aviator, or bomber, jacket
is a waist-length leather jacket
with a warm lining, like the
sheepskin seen here, originally
worn by Air Force pilots.
It has been widely adopted
as a fashionable jacket, new
or vintage.

Baseball jacket, 2010

Here, in a typical Paul Smith approach to classics—American or British—Smith has subverted the idea of team colors and logos and instead used summer pastels matched with the exotic pineapple motif of Hawaii.

Country jacket, 1994

This single-breasted, two-buttoned, brown corduroy jacket designed by Joe Casely-Hayford is an example of country styles that have been adopted as sophisticated city wear. It is known as the English Gentleman style.

Military jacket, 2006 (right)

Stefano Pilati for Yves Saint Laurent has designed a jacket with military references. The jacket has a Nehru collar and the cutaway fronts of the 19th century combined with epaulets and the pleated pockets of a battle jacket.

Jeans

The word "jeans" derives from Gênes, the French name for Genoa, Italy. It described the hard-wearing pants made of coarse fabric worn by the port workers. However, as a staple part of men's wardrobes, they derive from, and are identified with, the United States. The heroic cowboy image evoked by jeans has been immortalized in movies such as *The Magnificent Seven*, and reinforced by rock 'n' roll stars. Today, many companies specialize in jeans manufacture and most major designer brands have a jeans line.

D&G, 2010 (above)
D&G was originally set up in 1994, in Milan, as a denim line and offshoot of the main Dolce & Gabbana brand. Decoratively ripped jeans are a young glamorous revival of punk fashions.

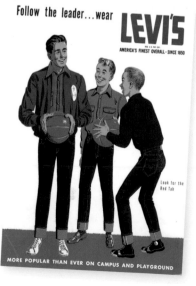

Levi's 501 jeans
Jeans were invented by Levi Strauss and tailor Jacob Davis in 1873 as durable pants for the working men of the West. By the 1950s, jeans were being sold in the eastern states and became associated with rebellion thanks to movies, such as *The Wild One* (see page 34).

Vince, 1960 (below)
These jeans were cut in order to display a well-toned body that was looked upon as more European than British in 1960. They were bought by a model who worked in Vince, the first men's boutique in Carnaby Street in London.

Alexander McQueen, 2008 (left)
Here, the three-quarter length jeans are part of a 1950s rockabilly theme. McQueen has exaggerated the skinny youthful pants by teaming them with an oversize lounge jacket.

Elvis Presley, 1950s (right)
During the 1950s, some companies, such as Wrangler and Lee, set up as competitors to Levi's. The image of jeans and denim clothing was given a new boost when worn by rock 'n' roll stars such as Elvis Presley.

Pants

Pants for less formal occasions have been particularly affected by developments in materials and fashion in the 20th century. Rules are no longer followed by designers, and one collection can show both skinny and baggy cuts at the same time. Fabrics and styles, such as leather and the military, are revisited by some designers in order to explore and rework their associations. Other designers—such as Gaultier and McQueen—challenge conventional views of masculinity in their use of cut and color.

D&G, 2010
These leather pants, part of the summer 2010 collection, demonstrate how fabrics no longer have to be seasonally led. The image of a wealthy young European is also very different from the American 1950s biker or rock star.

Rock 'n' roll, 1960
This photograph shows the popularity of leather clothing in the 1960s among American and British rock 'n' roll singers. Gene Vincent, on the right, was known for wearing full leather suits while performing.

Alexander McQueen, 2005 (left)
In this collection, McQueen experimented with a combination of plain military garments combined with colorful decorative pieces. Here, he mixes baggy gray combat pants with a top covered in Indian mirror embroidery.

Rockabilly, 1980
These flamboyant pink pants were part of an early 1980s London rockabilly style. They were inspired by the clothes worn by the American rock star Eddie Cochran.

Gordon Deighton, 1968 (right)
Tie-dyed cheap cotton garments were usually associated with the hippie style of dress in the late 1960s, but these pants were made of tie-dye silk and sold in the upscale London department store Simpsons of Piccadilly.

Shirts

Until the 20th century, shirts were mainly underwear and largely unseen, hidden away under other garments, except for their collars and cuffs. Soft-collar attached shirts were worn for sports, such as cricket, in the late 19th century, and gradually shirts became more visible. For casual dress, when worn without a tie, designers can use the shirt to challenge traditional shapes and materials.

Pastel, 1968
This pink cotton shirt was designed by Gordon Deighton in 1968. The cut is reminiscent of a 19th-century collarless shirt and the decorative fronts are related to broderie anglaise, more often used in women's clothing.

Romantic, 1750–1800
This linen shirt is made from gathered squares and rectangles with a collar and cuffs. Its voluminous sleeves inspired the dandy shirt designs of the 1960s and the new romantics of the 1980s.

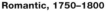

Mod, 2006 (right)
Hedi Slimane's collection,
which took the 1960s
as inspiration, shows
a deconstructed version
of the mod shirt. This
sleeveless variation
elongates the long skinny
silhouette and shows
off a youthful physique.

Art, 2010 (below)
In January 2010, Alexander
McQueen showed his fall
menswear collection in Milan.
The surface of this shirt has been
treated like a canvas, with the
same paint explosion continuing
on the balaclava and gloves.

Embroidered, 1540s
In the 16th century,
the exposed parts of
the shirt, collar, and
cuffs were ruffled
and embroidered.
This linen shirt has
a stylized design of
columbine and leaves,
which is embroidered
in cross-stitch with fine
blue silk thread.

Knit

Although knitting is an ancient skill, the modern popularity of knitwear has been associated with the use of sweaters in outdoor activities such as cricket, golf, sailing, and skiing. In Great Britain, there are regional styles of hand knitting. For example, Aran knit, from Ireland, uses natural wool and a cable needle to produce distinctive patterns, while Fair Isle, in Scotland, produces colorful geometric patterns in horizontal bands.

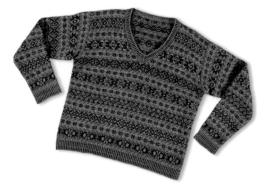

Alexander McQueen, 2006
McQueen has mixed references in this design, and subverted the connection between the Fair Isle sweater and the English country gentleman look. Instead, his knitwear is combined with a kind of mafia-style power dressing.

Fair Isle, 1931
This pattern is produced with a stockinette stitch, where a plain stitch is used for the ground color and a purl stitch for the colored wool. The technique also creates the distinctive striped ribbing that is associated with the Shetland Islands.

Snowflake, 2010 (right)

The D&G brand featured snowflake and reindeer patterned knitwear in the collection for winter 2010. This bright and cheerful pattern is often associated with skiing and Christmas.

Aran, 2010

Gaultier often features the distinctive Aran knit in his collections for both women and men, thereby presenting it as a luxury item. This form of hand knitting is valued for its texture and as an example of individual craft.

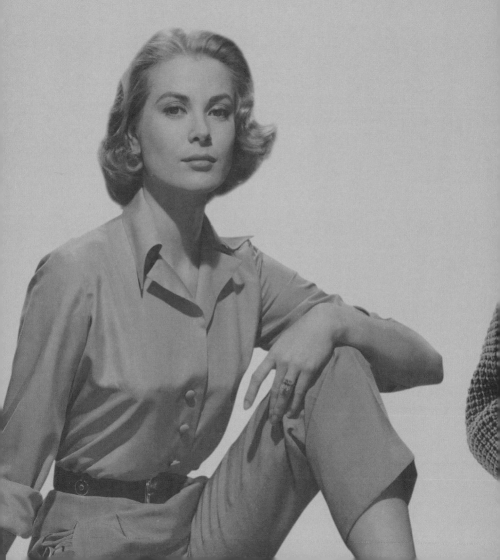

Female Casual

Introduction

Casual clothing, and separates, developed as a way of dressing from the end of the 19th century, when the lifestyle options for women widened. Many designers, from Chanel in the 1920s to Yves Saint Laurent and Mary Quant in the 1960s, promoted a more comfortable and practical way of dressing. Many of their initial ideas came from adapting men's garments and were inspired by themes, such as the military. During the 1950s, pants became more acceptable for casual occasions.

Nautical, 2006

Kenzo's summer 2006 fashion show had a nautical theme complete with a backdrop of waves. The nautical references are navy and white, sometimes with red, and flared sailor's pants. They are accessorized here with a miniature tam-o´-shanter.

Slacks, 1950s

This photograph illustrates how pants had become part of women's casual clothing by the 1950s. Very tightly fitting narrow pants, usually fastened with a side zipper, were fashionable in the late 1950s and early 1960s.

Military, 2010 (left)

Phoebe Philo, for Céline, shows a minimalist approach to the military trend in her short A-line skirt trimmed with leather. In a layered look, it is worn with shirt tails showing below the skirt's hem.

Humorous, 2010

Clothes for the different seasons can inspire designers to explore new references. Jean-Charles de Castelbajac has a reputation for having fun with clothes, and this skirt is a playful take on his paradise island theme.

Preppy, 1980s

The blazer teamed with simple unembellished separates, as seen here, was part of a style called "preppy," which was popular in North America and Britain in the early 1980s. A high neck and flat shoes completes the clean-cut look.

127

The Trench Coat

Gaultier, 2002
Gaultier's design of the trench has incorporated the traditional color, buttons, and buckles. However, the coat has been cut in a way that emphasizes the body and the collar frames the shoulders to reveal lacy lingerie.

Although this raincoat is particularly associated with Burberry (see page 110), other fashion houses, such as Aquascutum, also have a long tradition of producing this style. The trench coat became linked to the upper-class British lifestyle in the 1960s, and also to the secret service, through both movies and television series. From a classic British raincoat it has become an international style that designers continually explore with reference to the prevailing fashion trends.

Dior, 2010 (left)
John Galliano was inspired by 1940s movies, starring actresses such as Lauren Bacall, when he designed this version of the trench coat. The color, buttons, and belt are traditional, but the practical raincoat has become a decorative top.

Trench, 1963 (right)

This photograph, by John French, shows the trench coat as a typically British raincoat to be worn when pursuing country sports, such as shooting. It was also associated with British secret agents, such as Steed in the television series *The Avengers*.

Burberry, 2010 (below)

Burberry's summer trench coat follows the trend for ruching and large shoulders. This example is made of pink cotton in the style called "knotted epaulet" with the further military reference of a canvas and metal belt.

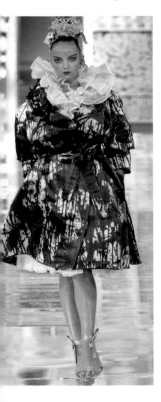

Lacroix, 2005 (left)

In this decorative trench coat, Lacroix has exaggerated the shape of the skirt and used a luxurious fabric, duchesse satin, instead of the usual gabardine. The surface has been hand painted and embellished with glittery beads for an evening effect.

The Jacket

Bar jacket, 2004
This Dior Bar jacket
from summer 2004
was inspired by the
padded peplums of
Christian Dior's
jackets from his
first collection in
1947. It was said
to be a response
to clients' demands
for a signature
Dior jacket.

The jacket for women developed as a practical item of clothing. In the 19th century, it was part of walking dress when a cloak or coat was not necessary. Developments in transport, and the use of cars and motorcycles, also made a jacket more practical than a coat. Historically, it had been used in sports, such as riding and then skiing, before becoming associated with smart but less formal wear. Many versions have been based on male jackets.

Leather jacket, 1990
Katherine Hamnett uses the
basic design of the black
leather Perfecto motorcycle
jacket as a reflective surface
for embellishment and as
a metaphor regarding the
environment. On the back
is written "Clean Up Or Die."

Spencer jacket, 1818 (left)
This jacket was named after George, 2nd Earl Spencer, who set a fashion by wearing a short jacket without tails in the 1790s. It was a practical garment that also complemented the neoclassical silhouette. (See also page 43.)

Blazer, 2006 (right)
This summer collection, designed by Nicolas Ghesquière for Balenciaga, was based on an ornamental dandy masculine style. Here, the conventional club blazer, with wide stripes and badge, is shown with a feminine ruffled blouse and low-rise hipster pants.

Military jacket, 1942
This blouson-style jacket with padded shoulders was based on an army battle dress jacket, which is particularly recognizable in the buckled waist belt. It was designed, probably by Victor Stiebel, under the wartime Utility Clothing program, when fabric was subject to rationing.

Blouses & Shirts

Miu Miu, 2010
This highly decorative blouse contrasts a prim business-wear collar with transparent body-revealing sections. Smocking decorates the sleeves and a luxurious effect is achieved by embellishment with crystals.

Blouses and shirts for women developed as a practical necessity, alongside the suit and the separate jacket and skirt, in the late 19th century. They were initially based on the man's shirt but made with finer fabric and shaped to show off a woman's corseted figure. Throughout much of the 20th century, the office collared shirt and the full-sleeve romantic shirt were dominant styles. Designers continue to explore these forms, taking inspiration from other cultures and deconstruction.

Edwardian, 1902
This photograph of Queen Alexandra shows her wearing a typical daytime outfit of high-necked lacy white blouse and skirt. The gathered sleeves and slight fullness at the front emphasize her fashionably small waist.

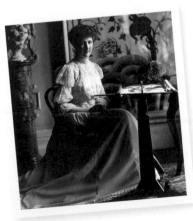

Dandy, 2006 (below)

This blouse was part of Balenciaga's Dandy collection. It uses historical references from 16th-century ruffs to the high-necked blouses of the 1900s. By restricting the colors to cream and white, Nicolas Ghesquière has highlighted the garment's texture.

Peasant, 1976

Yves Saint Laurent's blouse is from his Russian collection for which he also took inspiration from the colorful fabrics of Morocco. The simple cut, with large sleeves, offers full scope for displaying the embroidery.

Romantic, 2005 (right)

Gaultier, for Hermès, finds inspiration in the romantic peasant blouse in this example made of sheer silk chiffon. The motif is a form of toile de Jouy print, which since the 18th century has evoked French luxury.

Pants

Pants for casual wear, often based on men's pants, have been worn by women since the 1920s, but have become widely adopted only since the 1950s. Two major trends have been the Capri pants and the bumster. Emilio Pucci created the mid-calf-length tapered pants, taking their name from the location of the headquarters of his fashion house. Alexander McQueen introduced the low-rise "bumster" in spring 1995.

Bell bottoms, 1961
These Mary Quant pants show the popular fashion for bell-bottom pants that flared out under the knee. The cut references the pants worn by sailors in the 18th century, as do the four buttons on the front.

Leather, 2010
Christophe Decarnin's pants for Balmain show the long skinny-leg look that was first introduced by Hedi Slimane for men. New supple leather has been used in a bright red color that refers to the military.

Low-rise, 2001 (left)

These ultralow-rise pants are from Sonia Rykiel's winter 2001 collection. The design is based on the shape and cut of men's formal flannel pants with front pleats and an extension waistband.

Flares, 1971 (above)

Known as loons, from "balloon," these pants were made by Falmers in 1971. They have wide-leg flares and a male fly-front zipper fastening.

Capri pants, 1950s

Grace Kelly is wearing narrow-cut, silk Capri pants with a dark belt that emphasizes her slim waist. Worn with a silk shirt and espadrilles, the effect is casual but elegant.

The Skirt

Pencil skirt, 2010
This Christopher Kane skirt is a version of the formal pencil skirt that usually has the traditional kick pleat or vent, to allow movement, at the back. Instead, there are two visible slits at the sides and the fabric is a 1950s' gingham.

Until the 19th century, skirts were known as petticoats and usually seen only as a panel at the front of a gown. They developed as a separate item from the 1860s. With a need for more practical clothing, like the suit, and the popularity of casual separates from the 1950s, they became a staple of women's clothing. As such, skirts have reflected changes in culture, fabrics, and trends.

Full skirt, 1955
In the 1950s, when the jive was a popular dance, circular, or very full, skirts were the fashion. As can be seen here, they did not restrict the legs and enhanced the movements of the dance.

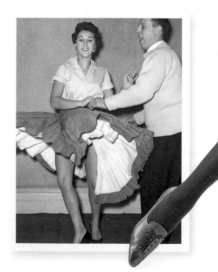

Stripes are cleverly used in this Nicole Groult suit to draw attention to the waist and figure. The short simple jacket focuses the eye on the skirt, which is cut on the bias and matches the stripes at the center front seam.

Mini, 1960s

The hemline of this skirt is just above the knee and shows the beginning of the miniskirt that reached its shortest version around 1970. The simple shape, probably of wool or synthetic jersey, is emphasized by the checkered pattern.

Ethnic, 1981

This outfit by Ralph Lauren is known as the Navajo look. Colors and patterns associated with the Navajo people formed the inspiration for the design of this woollen skirt worn with a silver and turquoise belt.

Knit

Body Map, 1985
In the 1980s, this company, created by Stevie Seward and David Holah, was famous for its unusual knitwear. This layered outfit was a typical example—based on a sheath dress with horizontal bands across the front.

Knitting was known in ancient times, but knitted sweaters and cardigans only entered mainstream fashion between the 1920s and 1950s, partly due to the popularity of sports, such as skiing, that required warm clothing. Machine-knitted garments have been available since the late 19th century, but there have been several periods of revivals in hand knitting. Designers have been inspired by traditional patterns and also by new decorative effects that knitting can provide.

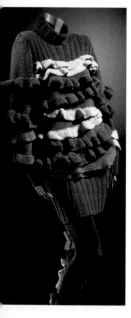

Sonia Rykiel, 2008 (right)
This designer has a reputation for fine knitwear in a signature stripe. The colorful short combinations here have a coordinating jacket, where the stripes are wider and more textured.

Sweater girl, 1950s (left)
V necks and three-quarter-length sleeves were fashionable in 1950s knitwear, but the most distinctive feature was the tight fit. They were popular with American actresses, such as Lana Turner, who became known as "sweater girls."

Knitted suit, 1967 (below)
Hand-knitted suits, as opposed to sweaters and cardigans, are unusual. However, in the 1960s designers such as Sally Levison, who produced this suit, reinterpreted traditional outfits in unexpected materials.

Elsa Schiaparelli, 1927 (above)
This hand-knitted sweater helped launch the designer's career in Paris; she later designed sweaters with trompe l'œil ties and handkerchief motifs. It shows the increasing demand for casual tops in the 1920s.

Male Leisure

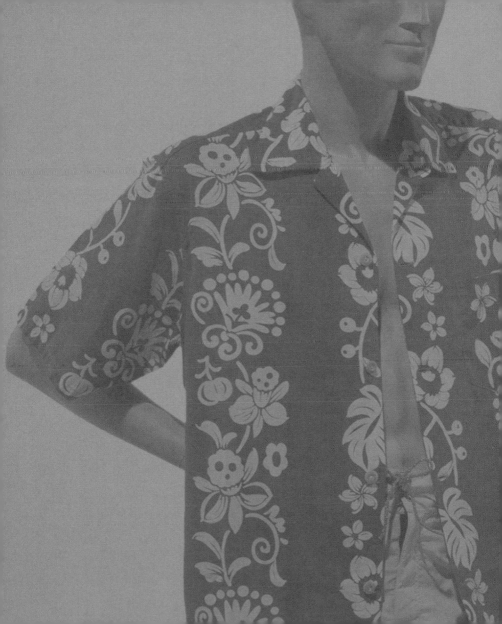

Introduction

Paul Smith, 2005
Smith has created a pair of flamboyant pants with a meandering pattern of red, pink, and yellow roses on a background of turquoise blue. The references are a mix of 18th century, hippie, and a subversion of the military.

Developments in men's clothing have been toward less restrictive dress whenever possible. Leisure time has given the opportunity to pursue sports and travel and to be more expressive in personal style. Since the 1970s, there has also been more emphasis on developing an ideal body whether muscular or, more recently, skinny. Designers have been inspired by sportswear, military, historical garments, other cultures, and new technology. Some use high-tech fabrics and futuristic styles, while others concentrate on traditional luxury.

Doucet Jeune, 1890
This is a luxurious item of machine-knitted silk underwear that was purchased with matching long johns in Paris. The Marquis of Anglesey, who was known for his lavish lifestyle, also had his crest embroidered on the undershirt.

Vivienne Westwood, 1988 (right)
This suit is a reworking of a classic Norfolk jacket and knickerbockers from the 19th century. It is made of pink and gray tweed and maintains the scaled-down and rounded features of the original with orb motif buttons.

Cyberpunk, 1991 (above)
Japanese designer Ryo Inoue has designed what he called a "fusion of the human body, technology, and media." It is an example of conceptual design, using new and unusual materials such as neoprene, plastic, metal, and rubber.

Versace, 2010
The global nature of fashion and its references are shown in the themes of this collection. A large djellaba-type shirt has been dip-dyed as if bleached by the desert sun and it is teamed with a French legionnaire's cap.

143

Active

Club wear, 1984
This stretch nylon outfit by Vivienne Westwood was worn as gay club wear. The fabric allowed movement and the design was inspired by soccer shirts, with their wealth of advertising images, and the protective underwear that is worn for sport.

The history of clothing for active leisure has been linked to work wear, sport, and dance. Inherent in those pursuits is the need for ease of movement and comfort, as well as style. In the 19th century, this meant looser, less tailored clothes, while in the 20th century, new textiles had a significant impact. Knitted and stretch fabrics, such as nylon and Lycra®, have enabled clothes to be lightweight and closely fitted to the body. Smart fibers allow comfort during exertion and include a new antisweat polyester.

Cricket, 1930
This photograph of the cricketer Terence Rattigan shows the outfit worn for sport that was copied for leisure wear. He is wearing cream or white flannel pants and a soft collar-attached shirt worn open at the neck with the sleeves rolled up.

Long johns, 2010 (right)
This outfit by Dolce & Gabbana is based on the idea of work wear. The long johns are teamed with a knitted top that has decorative "darning" and the worn theme is emphasized by the distressed leather work boots.

Norfolk jacket, 1900 (above)
This jacket with military origins became popular for country sports around 1860, and by the 1890s, was worn by young men in cities. It was made of tweed and had distinctive strips from shoulder to hem and a matching belt.

Hunting dress, 1975
Hunting dress, unlike other sporting outfits, has changed very little since the 19th century. This scarlet jacket and cord breeches were made by Bernhard Weatherhill, a Savile Row tailor in London and equestrian specialist.

Shirts

Shirts worn for leisure are free from the restrictions that apply to casual or formal dress and are an opportunity for comfort and self-expression. These shirts have increased in popularity since the 1920s, with the growth in leisure time and as vacations for working people have become more common at home or abroad. Leisure shirts can reflect the style of team sports or other cultures. The possibility of buying unusual items has increased since the introduction of the Internet in the 1990s.

Kaftan, 1973

This garment by London designer Mr. Fish is based on a kaftan. It is made of a luxurious silk and printed with an Asian ikat design. It is loose and comfortable and reflects the fashion for Eastern cultures.

Bowling, 1950s

In 1950s America, bowling shirts became part of fashionable dress. They were revived by the rockabillies in the 1980s. A classic bowling shirt is one color with the team logo machine-embroidered on the back.

Graphic, 2007
Stefano Pilati, for Yves Saint Laurent, has produced a garment inspired by the Hawaiian shirt. Instead of exotic fruit or flowers, a pattern has been created from a photographic image of faces in a crowd.

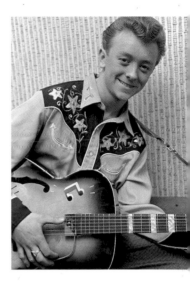

Western, 1958 (above)
By the 1930s, Americans were vacationing on ranches and this popularized the cowboy shirt. Typically, as here, the shirt has an embroidered yoke and "smiley," arrow-head pockets with mother-of-pearl snap fasteners.

Hawaiian, 1950s
This colorful shirt became known after World War II, when American servicemen took examples home. They were popularized by Alfred Shaheen, who improved the quality of design and construction; his clients included Elvis Presley.

The Striped Jacket

Sporting dress, 1890
This British fashion plate for dress suitable for sports shows a striped jacket worn with white pants. The jacket has distinctive patch pockets and is worn with a collar and tie, despite being a tennis outfit.

In the past, striped fabrics were considered to be working class because they were simple to produce and, thus cheaper. However, when the neoclassical style, with its focus on the vertical, became fashionable in the last quarter of the 18th century, stripes became a high-fashion design. Christian Lacroix has said that they give volume and three-dimensionality and that, for him, they represent modernity in any age. For other designers, stripes are closely linked to the summer, dress for bathing, the nautical theme, and sports.

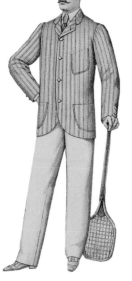

Versace, 2010
Versace's lightweight striped jacket, worn with white pants, emphasizes the link to the collection's theme of travel and hot desertlike conditions. The patch pockets reference 19th-century jackets and intensify the effect of the stripes.

Boating suit, 1880s–90s

This three-piece outfit, worn for seaside wear in the 1880s and 1890s, was based on the boating suit. The informal style is shown by the patched pockets and the cut of pants, which are wide and straight to allow movement.

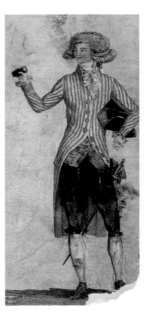

Neoclassical stripe, 1775–85

This French fashion plate shows that in the 1770s, the neoclassical stripe replaced the curving lines and floral motifs of the earlier rococo style. It was to become the most fashionable pattern in interior design as well as for men and women's clothing.

Cricket stripes, 1905

Captain Scratch was a comic character, a cricketer, who was invented by the comedian J. W. Hall. He is shown sporting a pink-and-white striped jacket, worn over a white shirt and teamed with a mismatching cap.

Beachwear

Beachwear developed during the 19th century, when sea bathing was thought to be good for health. The cultural shift from bathing to swimming made it necessary to streamline the clothing and develop suitable textiles. Elasticity was provided by knitted fabrics until they were superseded by mixes with elastic, nylon, and Lycra®. Various fashion trends have had an impact on beachwear design: basketball, the military, and the long shorts worn by surfers.

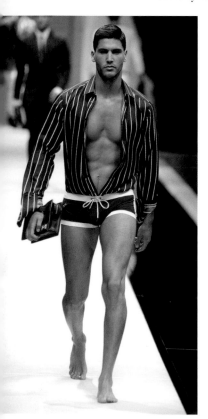

Bathing suit, 1900
In 1900, bathing suits were vivid because the fashionable pattern was stripes, but they were not made for swimming or comfort. The fabric used was wool, which became heavy and sagged when wet, and was susceptible to moths when not in use.

Dolce & Gabbana, 2010
These swimming trunks demonstrate the form-revealing swimwear of 2010. Daniel Craig, as James Bond in *Casino Royale*, set a trend for this style when he wore a similar pair in 2006, made for him by Grigio Perla.

Swimwear, 1939 (left)

This poster shows how swimwear developed in the 1930s into a more body-revealing shape. This man is wearing a deep cut athletic top, possibly made of knitted silk, with flannel trunks that fasten with a drawstring.

Alexander McQueen, 2005

This beachwear appears lightweight and comfortable, and is in tune with the fashionable military trend. The pattern of the shorts is camouflage combined with a 1950s small check, and they are worn over a tattoo inspired bodysuit.

Black bathing suit, 1914 (above)

Plain black bathing suits were popular between the 1910s and 1920s. The style had deep armholes and was more fitted than earlier versions. Although still made of wool, it had become a more athletic suit for the purpose of swimming.

Underwear

In the 19th century, long johns and a sleeved undershirt were the norm. By the mid-1940s, simpler sleeveless tank tops, jockey shorts, and boxer shorts were available. Since that period, both traditional garments and new designs, in modern stretch fabrics, have been produced. Luxurious textiles, such as silk and high-grade cotton, have become the signatures of particular companies. In the 1990s, Calvin Klein's branding and advertising promoted male underwear as a desirable, as well as an essential, product.

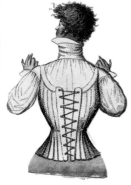

Corset, 1823
This illustration of a fashionable gentleman shows that men sometimes had recourse to the corset to achieve the ideal shape of their times. Since the 1980s, men have been more likely to visit the gym to keep trim.

John Smedley, 2010
This British company has a long history in the production of luxurious underwear. These contemporary versions of long johns and undershirt are made in England from Sea Island cotton, showing that there is still a market for traditional men's underwear.

Long johns, ca. 1900

These long underpants are made of machine-knitted silk, which was popular for high-quality underwear in the 19th century. It fitted well and was not bulky, so it did not ruin the finished look of a suit.

Calvin Klein

Calvin Klein's cotton stretch boxers, with the CK elastic band, turned men's underwear into a glamorous fashion statement. Calvin Klein advertising also promoted the fashion trend for displaying the top band above the pants.

Undershirt, ca. 1900

This silk undershirt is knitted in the most common color for underwear, plain white. Silk was particularly popular in the summer because it is cool and light. This undershirt is finished with a silk placket and real pearl buttons.

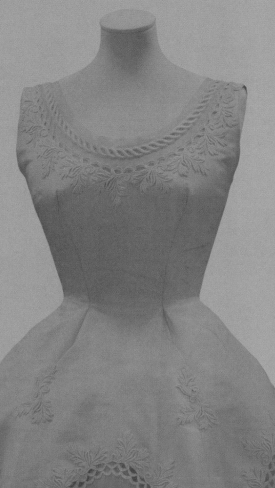

Introduction

Underwear, 1950s
The sculptural
shape of this Pierre
Balmain cream
silk embroidered
dress is achieved
because of the
understructure.
The strapless
petticoat has
a boned bodice
and the many
layers of net
give fullness
to the skirt.

At the end of the 19th century, women still wore corsets
and long gowns, despite participating in sports. Cycling
helped make breeches acceptable and after World War I,
these were worn for riding and skiing. From the 1920s,
sport, dance, and summer vacations focused attention on
youth and fitness. New lightweight materials and stretch
fabrics have produced garments that allow for movement
and are inspired by dance wear and sportswear.

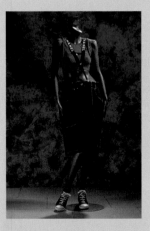

Hip-hop style, 1994
Karl Lagerfeld designed this
hip-hop inspired style for
Chanel. It consists of denim
baggy shorts held up by
suspenders, showing the
Chanel logo, worn with a
short two-piece Lycra® top.

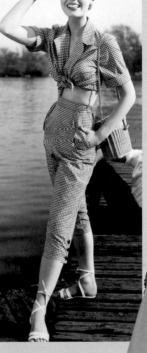

Summer wear, 1953 (left)
This photograph shows how much more lightweight, close-fitting, and body-revealing clothing for leisure had become by the 1950s. Pat Goddard wears Capri pants and a tied shirt top that shows a bare midriff.

Seaside, 1905
This striped and lace cotton dress was typical of the lightweight clothing worn for days at the seaside and boating. Notice the color theme of the blue-and-white stripes.

Shorts, 2010 (right)
Shorts have evolved from the culotte styles for tennis and the beach worn in the 1930s and the satin hot pants of the 1970s. This example by Jean-Charles de Castelbajac has gathered legs and the low rise of contemporary pants.

Active

Skiing, 1929
This Burberry outfit shows how pants were popular in the 1920s for skiing. The jacket is based on the uniform worn by the British Land Girls during World War I.

Women's clothing for sports in the 19th century were mainly based on men's garments. However, in the 1920s, tennis stars, particularly Suzanne Lenglen, helped to promote different styles and designers, such as Lanvin and Patou, opened sportswear departments. By the 1960s, simpler short A-line garments gave freedom to the body and designers, including Mary Quant, considered comfort as well as style. Jersey, denim, Lycra®, and other practical fabrics have been transferred to the high fashion collections.

American sportswear, 2010
Alexander Wang was inspired by football when he designed this layered outfit made of jersey sweatshirt fabric. The designer has a reputation for a relaxed, casual style interpreted for city wear.

Golf, 1908 (left)

Tailored outfits for sports and practical day wear were based on masculine clothing. This tweed jacket with leather decoration has the distinctive front strips and belt that show it was derived from a man's Norfolk jacket.

Riding, 1790s (below)

Riding dress in the 18th century consisted of a normal feminine skirt combined with a masculine style coat or jacket and vest. Here, we see the very high collar, lapels, and gilt buttons borrowed from men's tailoring.

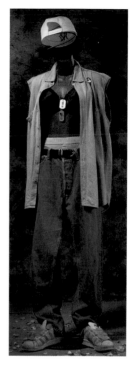

Denim, 1990s

DJ Slamma wore this outfit and said her clothing choices were governed by a desire to be sexy but also to dress comfortably and casually. The beginning of the trend for revealing underwear is clearly demonstrated here.

159

Seaside & Summer Wear

Sailor suit, 1930
This sleeveless suit of blue-and-white crepe de chine has the wide pants popular in the 1930s for beach-wear. The navy godets of the pants are matched with the long back collar.

Since the 19th century, summer clothes have been made of lightweight linens, cottons, and silks, often in pale colors. The nautical style became popular after 1846, when the four-year-old Prince of Wales, wearing an outfit based on that of the royal yacht's crew, was painted by Winterhalter. Since taking vacation became popular, summer clothing has often returned to this theme, incorporating references to pastimes reminiscent of summer, such as tennis and cricket.

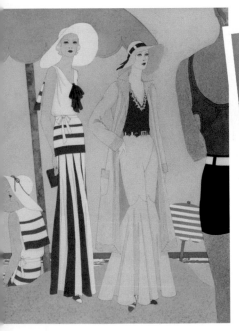

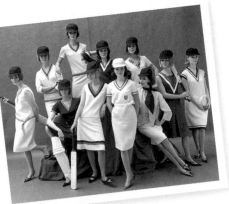

Summer dresses, 1963 (above)
Cricket, with its associations in England with summer and the color white, could readily be adapted for fashionable dress. This photograph by John French shows variations on the theme with sheathlike dresses and stripes defining the V necks.

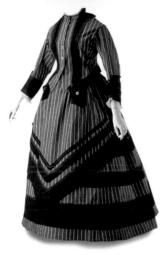

Sonia Rykiel, 2007 (right)
This navy-and-white striped dress has the sailor stripe and color theme of seaside clothing. The plunging scoop neckline is similar to a swimsuit, but the patch pockets and bow add decoration and the humor that is part of Rykiel's signature style.

Navy dress, 1872 (above)
The hemline, just above the ankle, indicates that this cotton and linen outfit was intended as a practical seaside walking dress. Comfort was also considered because although it would have been worn over a corset, the bodice is unlined.

Muslin dress, 1869
Fine cotton muslin was very lightweight and sheer, making it ideal summer wear. The elaborate shape worn over a bustle was fashionable for the 1860s although the train was not practical for a walking dress.

Swimwear

Between 1900 and the 1950s, the bathing suit developed from a large concealing garment of wool to a streamlined body-revealing swimsuit of cotton or nylon. Then, in France in 1946, Louis Réard and Jacques Heim developed competing versions of a two-piece swimsuit. Réard's version, called the bikini, thought shocking at first, was popularized by movie stars in the 1950s. Athleticism has replaced glamour in contemporary designs and innovative tan-through swimwear is one modern development.

Swimsuit, 1936–40 (right)
Cotton for swimsuits was an alternative to wool in the 1930s and 1940s before the use of nylon. The ruched panels at the sides gave some elasticity and decoration to the glamorous design.

Bathing costume, 1924
Chanel designed this pink knitted swimsuit and it was used as a costume in Diaghilev's modern ballet *Le Train Bleu*. Like the men's bathing suits of the period, it is a streamlined shape but made of heavy, bulky wool fabric.

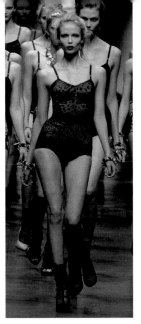

Dolce & Gabbana, 2010

Animal prints have been a recurring trend in fashion since the 1930s. This updated red version on synthetic stretch fabric has been used to create a streamlined swimsuit with a style inspired by the 1950s and modern leotards.

Bikini, 1953 (right)

Brigitte Bardot popularized the wearing of the bikini after her appearance on Cannes beach in 1953. The two-piece swimsuit, based on a bra and two triangles, was shocking because it revealed the navel for the first time.

Bathing, 1900

In this photograph, it is clear that the object of being in the sea is to bathe and not swim. The bathing suit is fashionably made of striped wool and it fulfills its purpose of concealing the body in a loose comfortable style.

Underwear—Structures

Crinoline, 1860
This crinoline has a framework of flexible spring-steel hoops that are connected by vertical woolen tapes. It was a light, pliable, and durable construction, which was not expensive to produce.

Understructures were used to give garments a particular shape. As women's lives became more active, they no longer wore the extreme designs of the past, except for special occasions, such as weddings, balls, and red carpet events. Corsets evolved from the tight lacing and stiffened bodices of the medieval period and hooped petticoats were worn by the end of the 15th century. Materials for stiffening evolved from whalebone to steel and plastic to create lighter, comfortable structures.

Panniers, 1778 (right)
The side hoops of the 18th century varied in shape from round to a flat front, as in this example. Like stays in a corset, the pannier was made of linen with whalebone or cane to form the hoops.

Corset, 1820

In 1820, the fashionable silhouette of the time was the narrow, vertical, and neoclassical. The corset reflects this with a high waistline, the bust pushed up, and long strips of bone down the center front.

Corset, 1950s (below)

The 1950s saw a return to the hour-glass silhouette, but the corsetry shown here demonstrates how materials with stretch, including nylon, had now replaced whale and steel boning. Suspenders now supported women's stockings instead of garters.

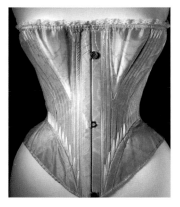

Corset, 1864

Blue silk, lace, and whalebone has been used to construct this corset. To achieve the fashionable curvy form, laces would be tightened at the back. In the 1940s, Hartnell and Dior were inspired by this shape.

Underwear—Lingerie

Until around 1900, underwear consisted of a chemise (shift) or camisole, drawers, petticoat, and corset. Brassieres date from about 1900, but they were not widely worn until the 1920s, when different cup sizes were manufactured. Since the 1980s, new stretch fabrics and dance wear have offered simple garments alongside the more structured corrective type. The use of colored silks with lace has created a sensual image of underwear, which has transformed it, on occasions, from functional undergarment to fashionable outerwear unashamedly on display.

Underwear, 1835
This outfit consists of a chemise, drawers, and corset. Drawers were introduced in the 1790s, when they were thought necessary for modesty because of the neoclassical narrow gowns of sheer fabrics that were fashionable.

Waspie, 1956
Waspies, made of elastic with boning, were designed in Paris in the 1940s. They reduced the waist to produce fashionable curves. It is worn over a camisole, similar to the 19th-century original, emphasizing this fashion revival in shape.

Black satin, 1942 (right)

This photograph shows the sensual combination of black satin and lace for a matching bra, underpants, and slip that was an alternative to more practical white and flesh colors.

Bustier, 1957

Flesh colored nylon and elasticized panels make this Berlei garment lightweight but functional. However, boning and wiring was still used to produce the required silhouette and the hook-and-eye fastening at the back would have required assistance.

Agent Provocateur, 1997

Designs inspired by the underwear worn in the 1950s by movie stars and pinups are the signature of this company. The matching bra and girdle have the 1950s central decorative panel and combination of black with a pale pastel shade.

Introduction

Male accessories have been subject to change because of the general move toward informality in dress and also the vagaries of fashion. Traditions that required respectable dress to include a hat, gloves, and a cane were abolished when youth styles dominated in the 1960s. However, there has always been a section of upper-class society that retains the rules of dressing with the "correct" accessories, and some designers have chosen to reinterpret traditional styles for a new generation.

Cravat, 1954

The actor Cary Grant is shown here in *To Catch A Thief*, a movie set in the south of France around Cannes. He is wearing casual summer clothes, including an open-neck shirt with a cravat instead of the more formal tie.

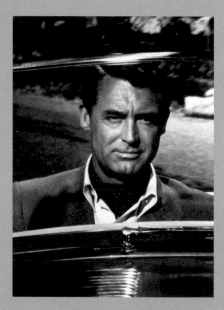

Smoking cap, 1870

This embroidered felt cap has a quilted lining for comfort. It would have been worn with a smoking jacket for smoking, or entertaining informally, at home. These garments were designed to protect other clothes from the smoke.

Formal day wear, 1924

Baron Rothschild, a wealthy aristocrat, is wearing the type of formal day wear that had changed very little since the late 19th century. He has a detached, stiff, fold-down collar with a silk tie and tie pin, plus a pocket handkerchief.

Tie, 1890s

Artist Aubrey Beardsley is wearing formal day wear including the fashionable neckwear of the late 19th century. The black silk cravat is tied in a flat bow over a white shirt and detached stiff collar.

Trilby, 2010

Bottega Veneta's fall/winter collection had a 1950s theme, and the trilby hat was popular in the 1950s for both summer and winter wear. Summer versions were made of straw and winter versions of felt. This winter style uses a high-gloss fur felt.

Boots

Between the end of the 18th century and the 1830s long boots were favored for every day. A wide range of styles appeared and many traditional boots date from this period. Country sporting wear and military-inspired styles were popular, as was the straight top, knee-high leather boot, named after the Duke of Wellington. Boots became shorter when pants developed new looser shapes. They have been revived since the 1950s and linked to youth styles, sports, and work wear.

Patent, 1967

Pierre Cardin designed these boots as part of an outfit with a belted tunic and pants called Cosmos. The narrow jersey pants tucked inside the boots so that the patent leather circles were emphasized and linked with the patent belt.

Biker, 2010

These long leather boots by Bottega Veneta have the heavy look of a biker's protective footwear. However, the high gloss makes them an extension of the leather pants and the look is city smart.

Top boots, 1840s (below)

In the late 18th and early 19th century, these boots were worn for day wear, but by the 1830s they were mainly reserved for sport. Their name derived from the turned-down top that displayed a paler leather.

Work wear, 2010 (right)

These distressed gray work-wear boots by Dolce & Gabbana are a stylish combination of different kinds of footwear. The design mixes top boots with the ankle-length, laced worker's boots of the 19th century.

Ankle boots, 1880 (left)

Around 1830, ankle boots replaced top boots for everyday wear and were worn under pants. This pair are made of patent leather and cloth, and fastened with mother-of-pearl buttons. This style of boot was also adapted for women.

Shoes

Buckle, 1830
Leather shoes worn with gilt buckles were no longer high fashion by 1830 but were retained for formal court wear. They were worn with breeches and silk stockings that showed off the leg.

Shoes were worn with breeches in the 18th century, but were used only for evening wear by the beginning of the 19th century, when boots were worn for daytime. Gradually, as pants replaced breeches, shoes replaced long boots. In the 20th century, there was a vast range of styles with laces, and different materials were used for summer, winter, and sportswear. Developments dictated by comfort led to the slip-on shoe of the 1940s. Designers today often reference historical and traditional styles in their footwear.

Oxfords, 1945 (right)
Oxford shoes were available from around 1910 and have remained a classic daytime shoe worn with casual and formal dress. The style has enclosed lacing with a distinctive cap seam that can, as here, have slight decoration.

Sandals, 2006

Sandals have been revived as fashionable footwear as part of the gladiator theme. These black ankle-length sandals by Raf Simons stand out in an otherwise white outfit.

Correspondent, 2006 (above)

By 1915 two-tone shoes, or correspondent shoes, were popular for resort wear. This example uses the contrast of black and white with a pointed shape, without a toe cap, to elongate the foot and emphasize the skinny look.

Loafers, 1945

This casual slip-on shoe originated in Norway and became fashionable in the United States and Europe in the 1940s because it was so comfortable. In winter 1993, designer Patrick Cox revived this traditional style and made it high fashion.

Hats

Pork pie, 1950
The singer/
songwriter Johnnie
Ray wears the pork
pie hat that became
associated with jazz
and swing music in
the 1950s. It was
similar in size to a
trilby but with a flat
top and short crown.

Until the 1960s, hats were part of the traditional way of dressing. Many hats worn in the first half of the 20th century originated in the 1800s, such as the top hat and the bowler. Some styles became associated with certain groups: the bowler with the English city gent of the 1950s and the cloth cap with the 1930s working class. Since the 1950s, new headgear has been associated with sports, music, and revivals of traditional styles.

Bowler, 1958
Acker Bilk wears his
signature bowler hat.
This domed hat, stiffened
with shellac, was
originally created for
William Coke's
gamekeepers in 1850,
by Thomas and William
Bowler, but rapidly
became city wear.

Trilby, 1960
Bing Crosby was known for his love of different hats. In this photo, he sports a kind of narrow trilby. It has a flat top and is worn with the brim turned down.

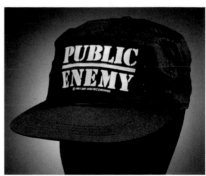

Dolce & Gabbana cap, 2010
The flat cap links back to medieval times but is mainly associated with the 19th century, when men of all classes wore them, albeit in different quality cloths. Tweed caps were worn by the upper classes for sports during the 1920s.

Baseball cap, 1988
This baseball cap was worn with an outfit representing the B-Boy style provided by the hip-hop clothing suppliers Four Star General. The traditional sporting cap is here part of a black consciousness look.

Neckwear

Stock and cravat, 1805

This miniature of Colonel Cuppage shows the white neckwear of the period. The points of the shirt are completely covered by the stock and cravat that is tied in a modest bow, below which the shirt ruffle is displayed.

Changes in neckwear relate to developments in the shirt, the vest, and the jacket, all of which frame the face and neck. At the beginning of the 19th century, the fashion leader Beau Brummell promoted the wearing of clean, white, starched linen neckwear in a variety of styles. During the 20th century, everyday neckwear has been reduced to a narrow tie, cravat, or muffler—but it still allows the wearer to display individual choice of color and pattern.

Collar, 1890

Detachable collars were worn from the 1820s, and this type of standing collar reached its maximum height during the 1890s. This collar is made of starched linen and is attached to the shirt by studs at the back and front.

White tie, 1930s

Fred Astaire wears the white bow tie and the starched wing collar that completed the most formal evening dress. White bow ties were made of the same cotton piqué as the white shirt front and vest.

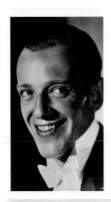

Muffler, 2010

Mufflers, or scarves, were an essential part of men's wardrobes at the beginning of the 1900s. This elegant Ferragamo evening muffler relates to that tradition and is worn to display the luxurious fabric and silk fringe.

Tie, 1960

French singer Johnny Hallyday is dressed in the minimal style of the late 1950s and early 1960s. He is wearing a fashionable, narrow tie with the simple 19th-century four-in-hand knot.

Female Accessories

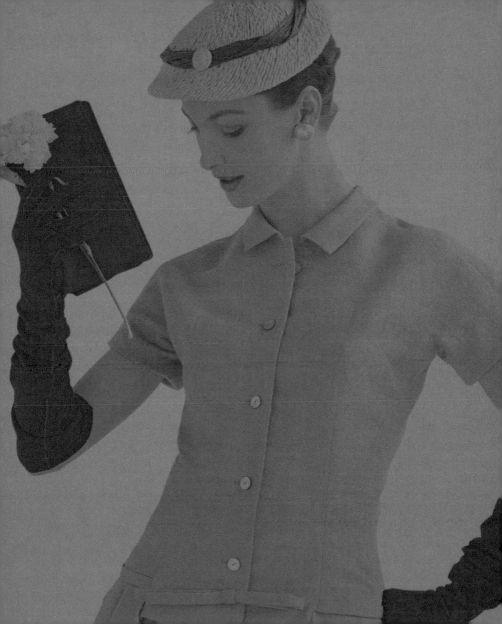

Introduction

The range of accessories available for women expanded from the late 18th century. Some items, such as fans and parasols, largely disappeared from normal use during the 20th century, while others, such as hats, have become confined to particular occasions. With the adoption of a less formal style of dressing in the 1960s, the rules concerning which accessories were necessary to look respectable were relaxed. Since the 1980s, fashion designers have focused on purses and footwear that portray the brand's signature.

Dior, 1955
This photograph by John French shows a Dior day outfit that is formally accessorized—in accordance with the rules of dress in the 1950s—with clutch purse, gloves, and hat.

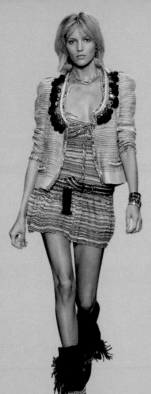

Signature bag, 2010
This leather bag shows the signature monogram and pattern of Louis Vuitton items but updated in line with Marc Jacobs' summer theme of the new-age traveler. Bohemian details include beads and decorative tassels.

Straw hat, 2010 (below)
Model Angelina B wears an open-mesh textured Antonio Marras straw hat with silk blooms that match the colors of the dress. The flower-strewn hat completes the designer's theme of nostalgia and innocence inspired by early Italian movies.

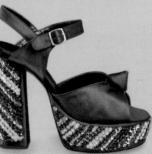

Boots, 2010
Isabel Marant's summer outfit shows a decorative, informal style based on a bohemian traveler theme. Marant's leggy look is emphasized by the fringed black boots that are shown for summer wear.

Platform shoes, 1972
Biba was known for designs that were inspired by the past and for rich colors, such as the blue satin shown here. Art deco and 1930s Hollywood inspired the diagonal bands of beaded and diamante decoration on the high platform sole and heel.

Purses & Bags

Kelly bag, 1956
The Hermès bag, with its distinctive horizontal clasp and shape, originated in 1935. It was renamed when Grace Kelly became Princess Grace of Monaco and was photographed with the bag in 1956.

In the 18th century, a pair of pockets were worn under full skirts to keep small items such as handkerchiefs. The alternative was a simple bag with a drawstring used for needlework. As gowns became narrower in the early 19th century, it was more practical to carry a small bag called a "reticule," the forerunner of the modern handbag. During the 1950s, many fashion brands developed signature bags distinctive in shape, color, and decoration.

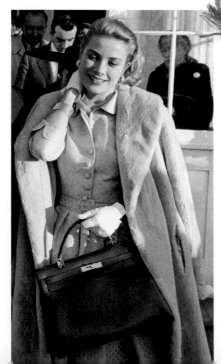

Judith Leiber, 1983
Leiber is known for her highly collectible, limited edition evening purses, such as the cup cake bag used in the movie *Sex and the City*. This Egg bag is, typically, hand-jeweled and has a coin purse, mirror, and comb.

Moschino, 1996 (left)

Moschino started his label in 1983 with his trademark approach of provocative and humorous style. This bag is now highly coveted. It has a classic shape but the surreal motif of luxurious melting chocolate.

Gucci bag, 1969 (below)

Guccio Gucci started his business around 1906, making saddlery in Florence. By the 1920s, luggage and handbags were also being produced. This bag has the colors and equestrian signature "bar and bit" details typical of the 1960s house style.

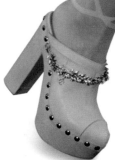

Chanel 2.55 bag, 2010

This summer shoulder bag is a version of the famous bag originally designed by Gabrielle "Coco" Chanel in February 1955 and known as the 2.55 bag. Its defining features are the quilting and chain-style straps.

Stiletto Shoes

The term "stiletto" derives from a type of slim dagger and was first used in the 1950s to describe shoes that had heel tips of just ¼-inch diameter. This was made technically possible by means of a supporting metal shaft within the heel. Stilettos have generated much excitement and sales for fashion houses in recent years; the highest-ever thin heels of 5 to 6 inches have been produced by shoe designers, such as Christian Louboutin, Manolo Blahnik, Jimmy Choo, and Pierre Hardy.

Marie Antoinette shoe, 2009

This platform shoe, with Christian Louboutin's signature red sole, has a 6½-inch high heel. It is one of a limited edition produced with the embroidery house Lesage. The design is inspired by Marie Antoinette, whose portrait is featured on the front of the ankle strap, and it is trimmed in ribbon just like an 18th-century bodice.

Evening shoe, 1960s

Designed by Roger Vivier for Dior, this silk court evening shoe has a classic 4-inch stiletto heel. The 18th-century-inspired decoration of beads, thread, and silver shows off the stiletto by stopping just over the top of the heel. It is additionally highlighted by the shiny black sole.

Stiletto, 1990s

Manolo Blahnik's creation combines a 1950s stiletto heel with a modern curved cutaway front. The uppers have a silk brocade inspired by 18th-century styles.

Pirelli shoe, 1980s

Manolo Blahnik is credited with reviving stilettos in the 1980s. The leather Pirelli tire print uppers of this design make a connection between the sexual power of high-speed cars and high-heeled stilettos.

The original stiletto

The commercial (as opposed to the fetish) stiletto originated in the early 1950s and is usually credited to the French designer Roger Vivier—although some claim it originated in Italy. This example, dating from 1954, is a fine chisel-toed, silk court evening shoe with an upper and heel covered in tulle.

High to Flat Shoes

Until the 19th century, shoes were the main type of footwear available to women, and when streets were muddy, there was a practical reason to wear high shoes. Other factors include technical advances in materials and construction, as well as associations with status and fashion. When skirts rise, attention is drawn to the ankle and foot. Designs can be inspired by practicality, historical sources, and the search for innovation. Recently, fashionable shoes have become an even more covetable item than purses.

Platforms, 1938

Ferragamo worked in Hollywood and then Florence in 1927, designing shoes for several glamorous movie stars. He developed many innovative new styles, including the kind of wedge sole seen here in suede-covered cork.

Satin flats, 1830s

These bright shoes would have been worn under an ankle-length skirt that drew attention to the feet. Silk, flat shoes would have been worn only indoors or on special occasions because they were fragile.

Roger Vivier, 1961

One of the shoes most associated with Roger Vivier are the flat Pilgrim Pumps of 1965, designed for Yves Saint Laurent and worn by Jackie Kennedy. These low-heeled shoes with a buckle were their forerunner.

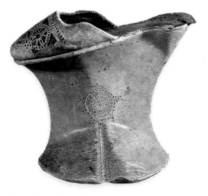

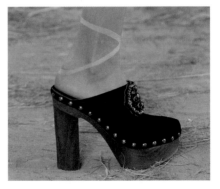

Chopines, 1600

Chopines were very high, backless shoes or overshoes that were first worn in Venice by fashionable prostitutes and aristocrats. These are a modest height of 7½ inches and are made of decorated, punched kid leather and pinewood.

Clogs, 2010

Chanel's clog has a high, thick heel with a platform sole inspired by the 1970s. The decorative buckle derives from the 18th century and links to the Marie Antoinette fantasy farm, which was the theme of Lagerfeld's collection.

Boots

In the 19th century, boots became popular for women in the form of top boots and half boots based on masculine styles. Laces and buttons were often replaced by elastic sides because they were easier to put on. After the 1850s, a different last was used for the left and right foot, which improved comfort. By the 1960s, when skirts were short, long boots were used to draw attention to the newly exposed legs.

Ankle boots, 1965
Courrèges was inspired by space travel and youth when he designed these white leather ankle boots to be worn with short skirts or slim pants. The narrow shape was fastened by a back zipper and Velcro placket.

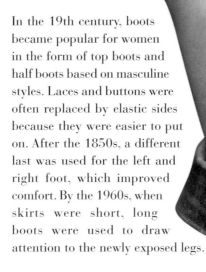

Isabel Marant, 2010
Camouflage pattern, fringe trim, and silver chains are used together here to create a highly textured effect that links to Marant's theme of travel. They demonstrate the recent fashion for boots as summer wear.

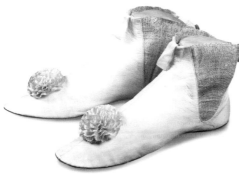

Wedding boots, 1865

Ankle boots of this design, flat with elastic sides, were common for everyday wear in the mid-19th century. The silk rosettes were extra decoration for evening or, as here, an occasion like a wedding (see page 93).

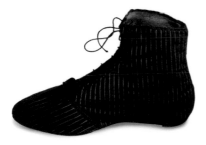

Half boot, ca. 1812

This neat front-lacing, half boot is made of a durable, striped, cotton jean fabric that was used as a cheap alternative to leather. It has a small heel with a leather sole that made it practical for outdoor day wear.

Long boots, 1966–69

These Pierre Cardin boots are made of shiny PVC, but, for comfort, they are lined with fabric and have side zippers at the ankles. Long boots were worn with 1960s miniskirts and popularized by the British TV series *The Avengers*.

Wraps & Scarves

Silk shawl, 1800–11

This shawl is a British imitation of a Kashmir shawl. The design, with a plain center and deep borders, is similar to the original Indian variety, but the motif of a bell flower, instead of a pinecone, is European.

Folding materials around the head, neck, and body is an ancient means of keeping warm and displaying fine wool, silk, and fur. The Indian Kashmir shawl, made of goat's hair, was a very expensive high fashion accessory in the 1790s, which was revived as the pashmina craze of the 1990s. Since the 1950s, movie stars, such as Audrey Hepburn and Marilyn Monroe, have been pictured wearing scarves and stoles, helping to give them a glamorous and sophisticated image.

Adèle Astaire, 1920s
Exotic gold or silver lamé fabrics added rich textures to the simplicity of 1920s fashions. Turbans and fabrics folded to create headbands, as here, echoed the small shapes of cloche hats and bobbed hairstyles.

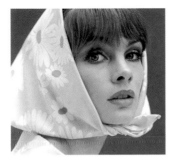

Headscarf, 1960s

Jean Shrimpton wears the minimal style of headscarf that does not cover the neck. The daisy pattern and small shape links to the fresh, youthful fashions of the 1960s.

Fur stole, 1950s

Fur stoles were very popular in the 1950s. Worn with a tight-fitting evening dress, they were associated with movie-star, red carpet glamour. They were often made from the skins of several fox or mink.

Hermès scarf, 2008

Hermès scarves, which have become collectible items, have inspired this swimsuit and matching flowing wrap designed by Jean-Paul Gaultier. The position and type of the design on the silk square identify it as an Hermès piece.

Hats

**Black straw,
ca. 1910 (below)**
The scale of this
hat by Henry
reflects the large
hairstyles of the
time. Long hat
pins would have
anchored it to the
hair. It is trimmed
with purple
artificial flowers,
reflecting the
owner's name,
Heather.

There is a long history of women covering their heads both
indoors and outdoors to present a respectable appearance.
Hats worn outside have been created partly for protection
and also as part of a fashionable outfit. Straw and similar
fibrous materials have often been used for summer hats.
Shape is often dictated by function: to protect the face
from the sun—but also to draw attention to
the face or neck.

Kenzo, 2006
In a Little Bo Peep theme,
Lily Cole wears an 18th-
century-style straw hat
combined with a 1970s-
inspired maxi dress. The plain
straw has a pronounced crown
with black ribbons anchoring
it at a jaunty angle.

Elsa Schiaparelli, 1938 (below)

Schiaparelli's wearable version of a simple hat, from her Pagan Collection, reflects her use of surrealist images. The woven grass hat has pink and green metallic flies and beetles seemingly crawling over the surface.

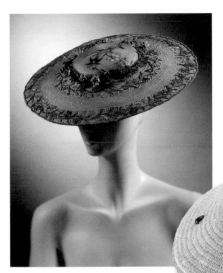

Straw hat, 1760

The round shape of this straw hat is typical of the hats worn for day wear from about 1730 by working-class women. However, the decoration here, using braided and dyed straw, would have made it a more fashionable item.

Otto Lucas, 1954

Dyed black, braided straw creates the curves of this hat that sweep down at the front and up at the back in a similar way to 18th-century hats. Focus is given to the back of the neck.

Jewelry

JEWELRY

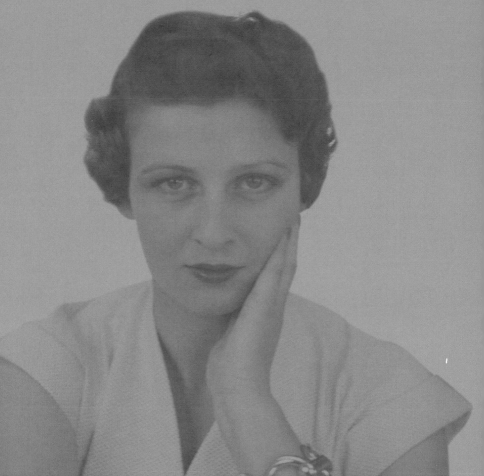

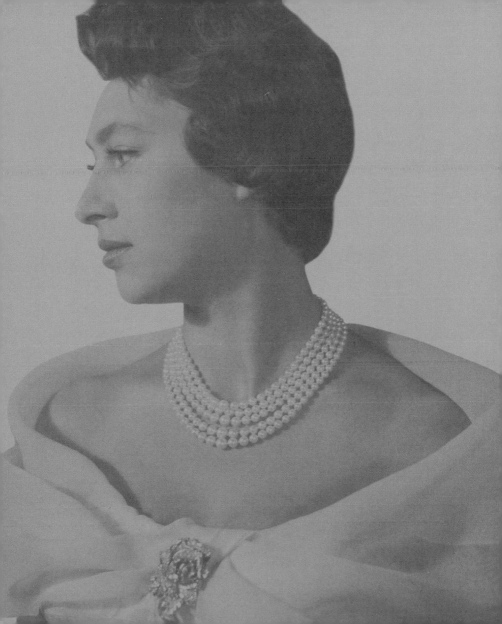

Introduction

Jewelry for men and women has reflected changes in fashion as well as technical and cultural developments. However, the materials used are more durable than textiles, and that makes them far more suitable as items to pass on to others. Precious stones can easily be reset and altered to reflect the aesthetics of the time. One of the greatest changes in jewelry design has been the acceptance and growing value of costume jewelry and conceptual designs that do not always utilize expensive, precious materials.

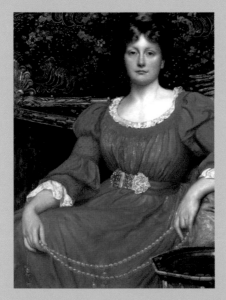

Costume jewelry, 1938
Gilt pinecones as decorative motifs, on silk and velvet ribbon, reflect the theme of natural objects found throughout Schiaparelli's Pagan collection. It demonstrates her interest in surrealism and the importance of the concept instead of precious materials.

Belt buckle, 1882
Mrs. Luke Ionides is wearing an aesthetic dress, which was an alternative to tight conventional dress. She is holding amber beads and wearing an ornate gilt belt buckle that was inspired by interlacing motifs and Gothic architecture from the Middle Ages.

Pearls, 1955 (below)

This photograph of Princess Margaret, shows how well a necklace can be set off by the right neckline of a dress. Here, the rows of pearls complement the line of the shoulders and lead the eye to the ornate brooch.

Hairpin, 1840s

Hair ornaments complemented the high hairstyles of the 1830s. The butterfly design had been popular since the fashion for natural motifs in the 18th century. This example is set with rose-cut diamonds.

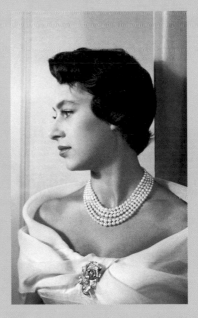

Chain bracelet, 1954 (left)

Princess Alexandra, cousin to Queen Elizabeth II, is wearing a silver or gold chain bracelet. The design, with large links, reflects the interest in machines, and more abstract forms, from the 1920s and the use of textured metal for day wear.

Materials

Gold, 1400–25
The shape of a heart and the use of gold to create this brooch emphasizes its message of precious love. The finely engraved inscription in French translates as "never to part," strengthening the message of fidelity.

Historically, gold and silver have been used to create fine jewelry and they were worked by the same jewelry maker: the goldsmith. While gold has been prized for its yellow color, several other metals could rival the gray-white of silver. Platinum, in particular, has been used for jewelry since the end of the 19th century. It has been prized for its pale appearance and its prestigious image due to its high cost—up to twice the price of gold.

Silver, 1899
Silver is a commercial metal because it is cheaper than gold, is malleable, and can be soldered. This waist clasp, produced for the British Liberty's Cymric range of jewelry, is based on sinuous lines. Machine processes have mimicked a hand-beaten piece.

Hans Stofer wanted
"Punk," his satirical chain,
to have a narrative, unlike
the usual livery. He uses
nonshiny, discarded
industrial steel and a silver
plaque that is stamped
"Lucky Devil."

Platinum, 1930
This platinum necklace of geometric links
can also be worn as two matching bracelets.
The platinum is used in thin segments,
probably due to its weight and expense.
The white metal acts as a foil to the
emeralds and diamonds.

Cut steel, 1810
Cut steel was popular for all kinds of
jewelry and accessories during the late
18th and early 19th centuries. In these
buckles and buttons, the shiny gray
polished facets contrast with Wedgwood's
blue-and-white jasperware.

Stones

Traditionally, the precious stones—diamonds, sapphires, rubies, and emeralds—have been associated with wealth and status. In the form of a ring, they can also be symbols of love and the intention to marry. Polished stones or cabochons were used in the Middle Ages to adorn metal-work. By the end of the 17th century, increased trade with countries, such as India, meant more gemstones were available and different techniques for cutting and polishing stones with multiple facets were developed.

Sapphire ring, 1830

The blue color of sapphires, which are usually from Sri Lanka, has made them popular for rings. For her engagement ring, in 1981, Princess Diana chose a sapphire surrounded by fourteen diamonds, from Garrard, London.

Diamond, emerald, and sapphire brooch, 1960

Schlumberger designed this brooch, in the form of two pinecones, for Tiffany & Co. of New York. The diamonds, sapphires, and emeralds are positioned to enhance the curved shape of the cones and jagged edge of the leaves.

Eternity rings, 1920–40

These rings, made of continuous circles of stones, have a long history symbolizing enduring love. Precious gemstones, particularly rubies because of their association with passion, reflect the sentiment.

Opal brooch, 1900

Opals were highly popular during the art nouveau period, when designers prized them for their unusual mix of colors. This brooch was designed for Marcus of New York and extends the opal's natural, vivid colors with enamel work.

Turquoise brooch, 1850

The bright blue color of turquoise made it very popular in sentimental jewelry of the 19th century and an appropriate present to bridesmaids. It represented the color of the wildflower forget-me-not, which was said to signify true love.

Fine Jewelry

During the Middle Ages, Paris became the most prestigious center for fine jewelry. Today, many companies are based in or near the 17th-century Place Vendôme, including Chaumet, Boucheron, Van Cleef & Arpels, Chanel, and Dior. Since the beginning of the 20th century, fine jewelers in New York and London have competed with Place Vendôme. Apart from the use of the highest quality materials, each luxury brand has developed its approach to design to maintain a unique identity.

Dior, 2010 (below)
This ring, of white gold, diamonds, and pink tourmaline, is from the La Fiancée du Vampire collection, in which designer Victoire de Castellane explores the theme of eternal love. Former President Sarkozy of France purchased this ring for his wife Carla Bruni.

Van Cleef & Arpels, 1930
This glittering brooch is thought to have been made by Van Cleef & Arpels. The company's designs involve decorative aspects and fairy-tale associations of gardens as well as technical innovations, such as transformable pieces and settings that are invisible.

Boucheron, 2010 (left)

The burlesque artist Dita Von Teese is wearing a silver snake bracelet with a diamond body and ruby eyes. Boucheron has used this motif since 1878—it is typical of the company style, which is called "extravagant bestiary."

Tiffany, 1960s

Tiffany & Co., New York, has built a reputation for American sophistication and glamour associated with guest designers and fine diamonds. This gold ring is elegantly set with two horizontal ovals of coral and diamonds.

Cartier, 1950s

Founded in 1847, Cartier is famous for the range of materials and colors it uses in its distinctive geometric, floral, and figurative pieces. This stylized African mask brooch was created at the end of France's colonization of parts of Africa.

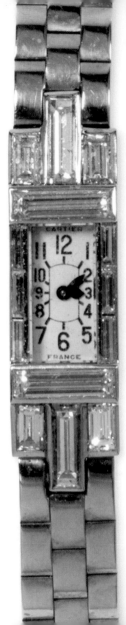

Female Jewelry

Pearls, ca. 1765
Pearl earrings and a necklace that fastens at the neck with a ribbon bow are worn here for day wear. The painting reveals how the whiteness of the pearls complemented the woman's pale skin, as well as the white fichu worn around her shoulders.

Jewelry for women became separated into day and evening styles in the 18th century. Pearls were the most popular form of day jewelry and parures, or sets, of glittering precious and semi-precious stones were worn for evening. Gemstones or paste copies were cut and faceted to shine, particularly by candlelight. This type of jewelry is still worn today for evening and red carpet events. Women also continue to wear crosses, rows of pearls, and chains.

Wristwatch, 1936
In the 1910s, wristwatches became popular for women and this luxury version was produced by Cartier. The narrow baguette style was so-called because of its similarity to the shape of baguette-cut diamonds, seen here around the face.

Gothic parure, 1848 (right)
Pugin designed this set of jewelry in the Gothic revival style that he developed based on the motifs, materials, and techniques of the Middle Ages. Notice the fleur-de-lys, cross, and the use of cabochon garnets, pearls, and gold.

Chain bracelet, 1890
Bracelets worn without matching pieces became popular in the 1840s. Léon Gariod specialized in creating articulated bracelets and chains decorated with gemstones. This example is made with large gold links and diamonds.

Emerald parure, 1806
Stephanie de Beauharnais was given this set of jewelry by Napoleon I and it is recorded in her portrait. The style is simple, but dramatic, as the color of the large emerald drops are enhanced by the open-back setting.

Male Jewelry

Until the second half of the 20th century, male adornment was mainly based around embellishing the clothes instead of the body. Embroidered or gemstone buttons were worn on coats in the 18th century, but with the severe plain cut of later tailoring, this practice disappeared. Instead, the focus moved to decorative neckwear, vests, and pants, with a display of pins and chains of fobs and watches. Wristwatches afforded a new opportunity to display the wearer's status and taste.

Stock pin, 1800–20

This stock pin was created from a baroque pearl and enameled gold. The skull motif is in the tradition of memento mori; signifying the brevity of earthly life compared to eternity. The pin is said to have been owned by Napoleon I.

Pocket watch, 1857

British Engineer Isambard Kingdom Brunel stands in front of the mechanism that will lower his steamship to be launched. He is formally dressed and shows the chains of a pocket watch that every man carried before the wristwatch dominated in the 1920s.

Fob, 1815–20

This fob, in the form of a seal, would have been attached to a watch chain and hung just below the waist from a small pocket in the pants. The engraved decoration illustrates a scene from the Battle of Trafalgar.

Versace, 2010

Since the 1950s, inspiration has been drawn from military identity tags for the design of neck pendants that focus attention on the body. Here, Versace shows three different necklaces, worn together, casually displaying the chest.

Rolex, 1998

The Oyster Perpetual Datejust wristwatch, designed in 1945, was worn by the fictional hero James Bond, emphasizing its image as both sophisticated and practical for a man of action. This classic version is made of steel and white gold.

Introduction

Hair and makeup complete an outfit to create the total look. Historically, styles for men and women have often had similarities. However, since men stopped wearing wigs and generally adopted shorter styles, women have had more choice. Apart from the options in length of hair, since the 1950s it has also been more acceptable for ordinary women, not only celebrities, to color their hair. Styles may have more variety, but, culturally, they still reflect associations with status, occupation, and age.

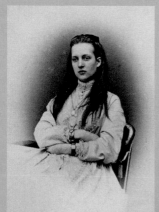

Long hair, 1867
Princess Alexandra of Denmark, wife of the future King Edward VII of England, was twenty-three years old, already married, and a mother when this photograph was taken. The large bow with loose hair was a youthful style only acceptable for informal occasions.

Peroxide, 1950s
Actress Jayne Mansfield was often referred to as "the poor man's Marilyn Monroe." Here, she shows the uniform peroxide blonde hair that had first been associated with movie stars such as "blonde bombshell" Jean Harlow in the 1930s.

Blond hair, 1999
Satya Oblet has said that he owed his success as a fashion model in the late 1990s, for companies such as Kenzo and Gaultier, to his radical new look. His dark skin contrasts with the blond hair, moustache, and beard.

Sleek hair, 1937
The Duke and Duchess of Kent showcase short, neat hairstyles of the 1930s. The overall sleek shape, with a center or side parting, was the same for both sexes. Curls and waves softened the look for women.

Court wig, 1800
This type of wig became popular around 1730, and by 1800, it was only fashionable for certain professionals, such as lawyers or doctors. The horsehair wig has its queue, or tail, in the black silk bag decorated with a rosette.

Male Hair—Facial

Goatee, 1998
Brad Pitt wears
a small beard on
the chin known as
the goatee. It was
popular in the
mid-19th century,
groomed to a point.
In the 1960s, it was
a beatnik look;
since the 1990s, it
has been associated
with artists and
intellectuals.

Beards, sideburns, and moustaches have traditionally been seen as manifestations of male strength and virility, but they have also been subject to changes in fashion. As men abandoned the wearing of wigs at the end of the 18th century, facial hair became more popular, particularly after 1850. Beards became associated with the serious and successful businessman, and moustaches were inspired by military figures. Facial hair became unfashionable between 1910 and 1960, since which time it has come to symbolize the artistic and intellectual.

Sideburns, late 19th century
Sir Richard Strachey was a British soldier and Indian administrator. He had very long sideburns: hair grown on the sides of the face and worn with a shaven chin. Sideburns were named around 1860 after an American general, Burnside.

Clean shaven, 1910

In the early 1900s, Gillette's disposable razor was available in the United States and Europe. This helped promote the clean-shaven look. By around 1910, beards had become so unpopular that the derogatory term "beaver" was used for a bearded man.

Beard and moustache, ca. 1890

Sir William Blake Richmond was a distinguished artist and professor at the Royal Academy in London. He wore his beard and moustache in a style that required minimal attention with razor and scissors and which complemented his long hair.

Moustache, 1870

The extreme moustaches seen here sported by Napoleon III and Kaiser Wilhelm were greatly admired. They required special care and gadgets, such as binders, made of silk gauze with elastic and leather straps, worn when asleep to retain the shape.

Male Hair—Revivals

Ponytail, 2007
Here, Karl Lagerfeld wears his hair in the style of an 18th-century powdered wig, with a tail. Since the 1960s, the style, worn without decoration, has been regarded as rebellious or bohemian.

Hairstyles for men can express many different things, from respectability, age, status, and occupation, to ideals and group affiliation. Since natural hair replaced wigs in the 19th century, the fashion in hairstyles has varied. Hair that framed the face with light curls was considered romantic in the 19th century. Long hair has been considered unconventional and associated with artists and intellectuals, while short hair has been particularly popular since World War II, because it is associated with the military, strength, and control.

Romantic, 1812
This style has curls brushed forward. It was inspired by the neoclassical, the dominant style in the arts and fashion in the early 1800s. Some men adopted a version of it around 2006.

Pompadour, 1959
In the 1950s, Cliff Richard adopted an Elvis Presley style. The pompadour was a modified version of the ducktail; it required long hair pulled back at the sides and front, then kept in place by grease.

Quiff, 2010
In Britain, in the 1950s, Teddy Boys (neo-Edwardians) wore the extreme ducktail or "quiff" hairstyle. The Bottega Veneta model here shows a new, curled, version of this look.

Beatle cut, 1963
Hair brushed forward, forming thick bangs instead of off the face, was regarded as shockingly long in the early 1960s. It echoed the geometric styles worn by women and was adopted by the young.

Female Hair—Revivals

In the 19th and 20th centuries, hair stylists and celebrities set trends in hairstyles. In recent years, fashion runway shows have also started to play an increasing role in creating trends. Advances in hair products have made it easier to re-create past styles without damaging hair or resorting to wigs. A deceptively simple approach to hair styling developed with 1960s celebrities, such as Jean Shrimpton and Brigitte Bardot, providing inspiration.

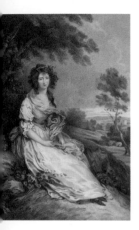

Gainsborough, 1785
This painting titled *Mrs. Sheridan* shows that hairstyles became more natural after the artificial styles of the 1770s, which were often achieved with wigs. The smaller shape shows hair full at the sides, contrasting with long trailing curls.

Dior, 2010
John Galliano has said that the late 18th-century inspired the theme of this prêt-à-porter collection. The hairstyle seen here is similar to that of Gainsborough's *Mrs. Sheridan* (left), with the addition of a long braid.

Braid, 2010
Alexander Wang showed a new messy version of the braid in his summer 2010 collection. Shown with clothes that were inspired by sportswear, it adapted a schoolgirl style, updated in a romantic form.

Beehive, 1962
Styles of the early 1960s were often narrow at the sides and high on the forehead, as seen here in this photo of the singer Dusty Springfield. This was achieved by combing it back and plenty of hair spray.

Unkempt, 1962
Brigitte Bardot had an impact on fashion in the 1950s and 1960s with a style in clothing and hair that was youthful but also glamorous. Her trademark blonde, tousled hair has inspired fashionable styles.

Female Hair—Cut & Control

Loose hair has had different cultural meanings in the West, from denoting a bride in the Middle Ages to an adolescent or even an immoral woman in the 19th century. As women became adults, hair was worn up, and until the 1920s, it was not an established fashion for women to have short hair. Bobbed hair was seen as a sign of modernity, and these associations were revived in the 1960s. Since that decade no formal rules have applied.

Controlled hair, 1862
Princess Alexandra wears her hair in a flat-crown style, where her hair is caught by ribbons or a snood. This photograph may be one of those taken to commemorate her engagement to the Prince of Wales in 1862.

Geometric cut, 1964
Vidal Sassoon gives Mary Quant one of his geometric hairstyles. His cuts were designed to work with the hair's natural qualities, and did not require lotions, sprays, and weekly salon visits.

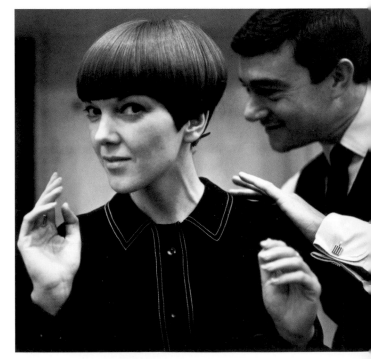

Short hair, 1798 (below)

This French fashion plate shows a short hairstyle that existed after the French Revolution. It was inspired by ancient classical styles, and some women cut their hair to honor those who had died on the guillotine.

French pleat, 2010 (left)

The chignon, or French pleat, was the sophisticated, severe hairstyle fashionable in the late 1950s, as worn by Audrey Hepburn in *Breakfast at Tiffany's*. This version from the Armani show is combed back high on top and flat at the sides.

Ponytail and bow, 1960s

Jean Shrimpton wears a neat style in which the hair is drawn back into a chignon or ponytail. The black velvet bow was called a "Tom Jones," after the hero of Henry Fielding's 18th-century novel of the same name.

Women's Makeup

Louise Brooks, 1928

The movie star Louise Brooks is seen in the heavy makeup worn for black-and-white movies in the 1920s. Companies such as Max Factor created makeup lines for ordinary women, and these were gradually accepted.

Historically cosmetics have been used to create both a heightened naturalism and an extremely artificial effect. In the 18th century, when only workers had tanned skin, fashionable women wanted their skin to appear as white as possible. At court, particularly in France, an extremely artificial makeup was applied. During the 19th century, a more natural look was the fashion. Heavy makeup did not become respectable until after the 1920s, following the popularity of Hollywood movies.

Nr. 46. 17. November 1936
Frankfurter Illustrierte

Das Illustrierte Blatt

Preis 20 Pfennig
Sechzehnter Jahrgang

Louise Brooks, die schöne Hollywooder Kinoschauspielerin, die für die Rolle der Lulu in der „Büchse der Pandora" ausgesucht wurde. Der Film wird augenblicklich in Berlin gedreht.

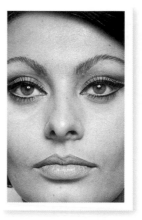

Sophia Loren, 1966
Sophia Loren was one of the Italian movie stars of the 1960s who has inspired designers and makeup artists ever since. Here, her flawless makeup, with its false eyelashes and curved but delicate eyelining, can be appreciated.

Soft Gothic, 2009

Gothic has been a recurring trend in clothing and, in the past, Gothic makeup has contrasted black, purple, and white. Prada's collection showed a softer version with smudgy brown eyes.

Amy Winehouse, 2009

Here, Amy Winehouse's makeup is an extreme version of styles that became fashionable in the late 1950s and 1960s. However, her liquid eyeliner is a more solid black and continues in a severe line toward her heavily defined eyebrows.

Tattoos, 2010

Peter Philips, Chanel's global creative director of makeup, has produced a series of temporary tattoos that last up to a week, playing with the Chanel symbols. This example shows chains and the double C.

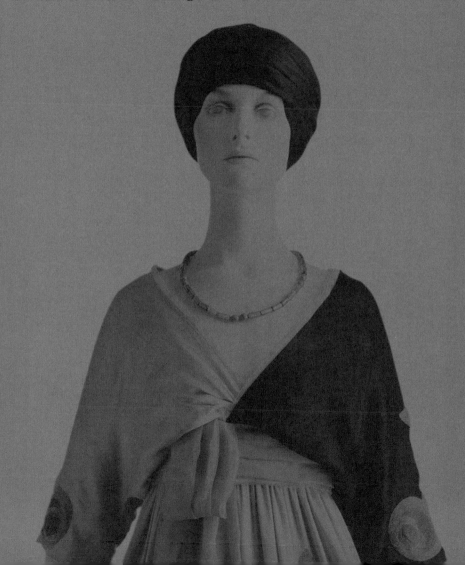

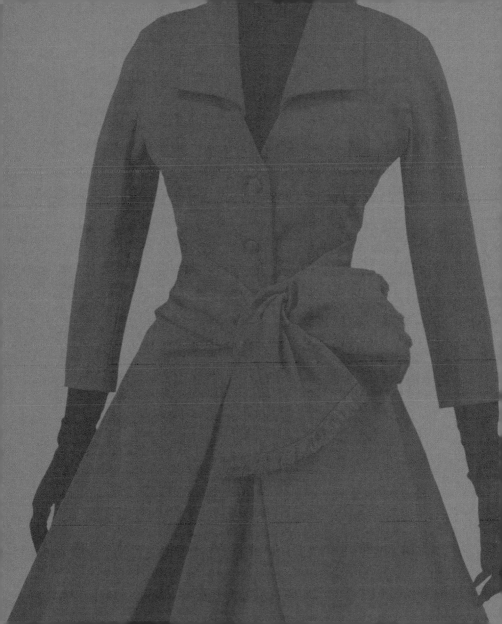

Introduction

Pierre Cardin, 1967
This blue crepe minidress shows the minimalism that Cardin is identified with. He has said that in the 1960s he discovered the perfect linear form for clothing and he has remained true to that aesthetic ever since.

The main fashion capitals—Paris, Milan, New York, and London—each have a unique history, which helps to explain the mix of fashion designers and fashion brands that exist today. Many designers, among them John Galliano and Karl Lagerfeld, design not only for their own label but for other brands, too. Companies that may have started supplying leather goods, such as Gucci and Hermès, have now developed clothing lines that benefit from the celebrity status of the designer.

Ralph Lauren, 2010
American classics characterize the approach of Ralph Lauren. As seen here, this can be expressed in a casual as well as formal style. Distressed jeans inspired by Levi's work wear are worn with suspenders and other items of menswear.

Chanel, 1922

In the early 1920s, Coco Chanel had a signature style that was based on the embroidery seen on this evening dress. The Russian embroidery house Kitmir exclusively carried out the work for her.

Yves Saint Laurent, 1968

Yves Saint Laurent produced many themed pieces that are still identified with him, including this beige gabardine safari tunic from 1968. The first version, which was shown in 1966, had the same shockingly low-laced front.

Hermès, 2005

Hermès has a reputation for high quality as well as a brand identity that communicates luxury. This simple swimsuit, designed by Jean-Paul Gaultier, uses the motif of Hermès tape, which is normally seen around purchases.

The First Celebrity Designers

Charles Frederick Worth, 1825–1895
The fashion company Worth operated between 1858 and 1956, and here is an evening dress, designed in 1881, by Charles Frederick Worth. It demonstrates his use of luxurious fabrics and embroidery with a form-fitting cut.

Until the late 18th century, the dressmakers, milliners, and tailors who created clothes for men and women were not known to the general public. In France, Rose Bertin was the first celebrity designer, and Louis-Hippolyte LeRoy became the first famous male designer. Neither of them worked away from the public eye, but were the acknowledged leaders of their profession. Throughout the 19th century, skills were passed on and the reputation of Paris as a fashion capital grew.

Rose Bertin, 1747–1813
Marie-Antoinette was Rose Bertin's most famous client and, on average, she ordered twelve grand court dresses, such as the one here, each season. Bertin was particularly known for her elaborate headdresses, here trimmed with pearls and feathers.

Jacques Doucet, 1853–1929 (left)
As with other designers, Doucet's early clients included royalty and actresses. Here, French theater star Mlle. Provost wears a 1909 silk embroidered gown with a train and feathered hat inspired by the Empire and Doucet's favorite period, the 18th century.

Paul Poiret, 1879–1944 (right)
Paul Poiret was one of the designers who claimed to have abolished corsets. This 1912 outfit, Sorbet, was one of his most famous designs; it was admired both for the shape created by the wired-out tunic and for referencing the East.

L. LeRoy, 1763–1829
LeRoy designed this court dress for the Empress Josephine. It has the form of the 1804 coronation dress he created, seen in David's painting. Notice the diagonal embroidery on the sleeve head and the knot of fabric at center back.

Designers to Brands

During the 1920s, fashions from Paris still dominated, although there was no longer the idea of one house being the absolute leader. Several fashion houses that operated then still exist today, referencing their origins in different ways. For example, Lanvin still uses the mother-and-daughter motif of the founder, and other houses create clothes inspired by their archives. Designers, such as Patou in the 1920s and Cardin in the 1960s, used their own names to strengthen their brand's identity.

Jeanne Lanvin, 1867–1946

Lanvin is the oldest surviving fashion house in Paris, and this 1935 purple silk and velvet evening cape and satin dress represent Jeanne Lanvin's love of rich Eastern colors and textures. She also had departments for children's wear and interior design.

Pierre Cardin, b. 1922

Pierre Cardin's Cosmos outfit from his menswear collection of 1967 demonstrates the same minimalist approach that he takes with womenswear. In the 1960s, this outfit, of comfortable and practical wool jersey, was seen as futuristic and unconventional.

Madeleine Vionnet, 1876–1975 (below)

Vionnet combined modern business practices with innovation in dressmaking. In this 1935 crepe cocktail gown, she created her distinct silhouette with bias cut fabric that clings to the body and falls in elegant folds.

Jean Patou, 1880–1936

During the 1920s, Patou had celebrity clients, such as Louise Brooks and the tennis star Suzanne Lenglen. He designed for the modern woman, as this simple but ornately embroidered evening dress, Byzance, shows.

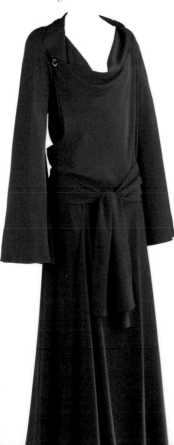

Cristóbal Balenciaga, 1895–1972 (above)

Some of the most dramatic designs produced by the Spanish designer Balenciaga are from the years just before his retirement in 1968. This silk gazar evening outfit, from 1967, was inspired by ecclesiastical dress, with its black, sculptural layers.

Chanel

Karl Lagerfeld, 1983

When Lagerfeld became creative design director of Chanel, Inès de la Fressange provided the feminine presence as model and spokesperson for the brand. In line with Chanel's elegant, practical style, here she is being fitted for a short-sleeve blazer.

Gabrielle "Coco" Chanel (1883–1971) had a two-stage fashion career: the 1910s to 1939 and 1954 to 1971. She created practical but stylish clothing for the modern active woman that did not require corsets. Ideas for outerwear sometimes came from men's clothing, but she was most famous for her suits and her simple black dresses of the 1920s. Accessories such as jewelry, bangles, pearls, and chains were a vital part of this style.

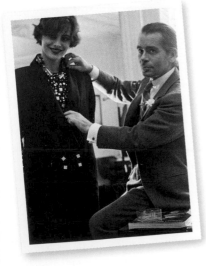

Mlle Chanel, 1965

This outfit demonstrates the pared-down monochrome style from Chanel's comeback period. The accessories show how important the black-and-white theme is to the complete look. Chanel herself is thought to have worn this ensemble.

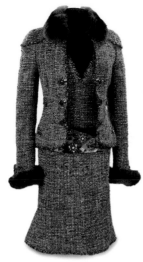

Prêt-à-porter, 2007 (right)
This outfit has some links to
the boyish summer styles that
Chanel adopted in the 1930s.
The wide matching bracelets
are a version of those worn
by Chanel, which were made
for her by the jeweler Fulco
di Verdura.

Karl Lagerfeld, 2003 (above)
The designer has played with
the stereotype of the Chanel
tweed suit, for day wear, from
the 1950s. Here, the gold
bouclé fabric is combined
with beads and fur to create
a luxurious evening outfit.

Haute couture, 2009
Karl Lagerfeld has often
referenced Chanel's liking
for black and white by
producing collections
with this color theme.
The white outfit shown
here is made from a
paper fabric created
by the embroidery
house Lesage.

DESIGNERS Dior & BRANDS

Y line, 1955
Dior's Y theme can be seen in this cocktail dress in the deep line of the neck and the inverted Y in the skirt's pleats. This silk grosgrain dress has the typical boning in the bodice and layers of net to support the skirt.

Christian Dior (1905–1957) created his fashion house in 1947 and became an instant success when his first collection was described by a journalist as the "New Look." His styles were a radical departure from the short narrow outfits of wartime. Dior was inspired by the colors and fabrics of the 18th century, and the bows and the hourglass curves of the 1890s. His designs often required boning and support from stiffened petticoats to achieve the desired shape.

Black swan, 1949–50
This dress represents Dior's designs from the late 1940s that used flying panels to produce unusual shapes. The boned bodice in this dress is fastened to a skirt that has silk velvet panels positioned to give the impression of a bow.

John Galliano, summer 2010 (left)
John Galliano became the designer at Dior since 1997, and this dress from his haute couture collection was inspired by the tailored shapes and contrasting panels originally created by Christian Dior.

Marc Bohan, 1967
Marc Bohan replaced Yves Saint Laurent as designer at Dior in 1960, and he remained in the position until 1989. This evening dress, of black silk organza and ostrich feathers, combines youthful elegance with exotic fabrics.

John Galliano, winter 2010 (right)
The 18th century was a period that inspired Christian Dior, and it is a time Galliano returns to frequently for his own design ideas. Here, the beribboned lingerie theme of the boudoir combines with knitwear.

Giorgio Armani

Summer 2010
This single-breasted, two-button suit is worn casually, without a tie, with the collar turned up emphasizing the comfortable but elegant look that Armani is known for. The lightweight fabrics in shades of gray are typical of the style.

Armani (b. 1934) worked for Nino Cerruti before starting his own menswear label in 1974 and a womenswear collection in 1975. He had an enormous impact on men's tailoring in the 1970s and 1980s by showing supple and less structured jackets. His muted color palette also contributed to his reputation for contemporary and elegant design. He applies the same sophisticated approach to his women's collections, which appeal to business clients. Armani controls other lines for clothing, furniture, and hotels.

Winter 2008
Armani's 2008 collection had a color range of black to white with patterns and blocks of color. Here the texture of the gray tailored jacket contrasts with the black velvet of the loose cut pants.

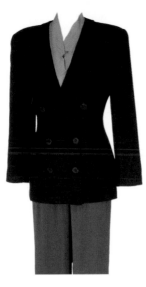

Haute couture, 2009

Armani experimented with textures and colors in this collection inspired by Puccini's opera *Turandot*. Fabrics were polished and shiny like the sequins in this example. Here, extreme shoulders, the trend for 2009, are combined with Armani's sleek silhouette.

Garçonne, 1980s (above)

This outfit, in different shades of gray, is an example of the subtle colors that Armani was known for in the 1980s. The shirt and the jacket have large shoulder pads that contribute to the powerful silhouette.

Summer 2007

The traditional gentleman's summer outfit and color theme of a navy blazer and white flannels has inspired this outfit. The pants have the contemporary low rise with the width of Oxford bags of the 1920s.

Hermès

Sheepskin coat, 2005

Hermès has constantly linked its line of goods to its origins as saddle makers. The house always produces some items in leather and this example is a contemporary shape made of traditional sheepskin.

Hermès was founded in 1837 by Thierry Hermès, a saddler, but by the 1930s, the company was producing a wider range of goods, including handbags and scarves. In the last twenty years, footwear and jewelry has been designed by Pierre Hardy and, since 2003, womenswear by Jean-Paul Gaultier. The most sought-after items are still the Kelly and Birkin bags. Luxurious materials, from leather to silk, and the colors orange and brown, are the signatures of this brand.

Leather ensemble, 2010 (right)

Britain's 1960s heroine Emma Peel is referenced in this black leather outfit complete with bowler hat and bag. It follows the trend for leather clothes and showcases the quality of the material.

Signature colors, 2005

These two neoclassical-style summer dresses are an example of the Hermès colors, orange and brown. The classic design perfectly illustrates Gaultier's simple, uncluttered image.

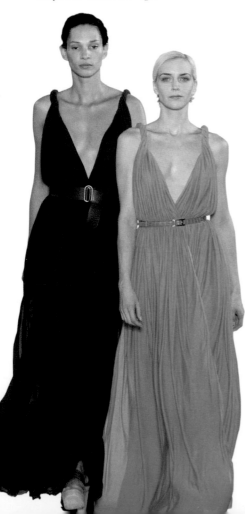

Scarf, 1990

Hermès started producing silk scarves in two collections a year, each with twelve designs, in Lyons in 1937. The scarf here, which has a heraldic design, is a typical example with vivid coloring and a hand-rolled and stitched hem.

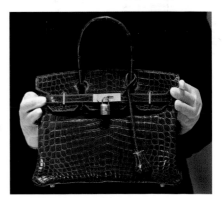

Birkin bag, 2007

The Birkin bag was created in 1984 after a chance meeting between the CEO of Hermès and Jane Birkin. The example seen here is one of the most expensive versions because it is made out of saltwater crocodile.

Prada

Although a company with historic roots, Prada has a reputation for a style that is eccentric, intellectual, and undeniably modern. The company was created in 1913 by Mario Prada, and sold luxury objects, including leather cases, watches, and evening bags. Since 1978, it has been run by Mario's granddaughter Miuccia and has branched out into selling clothing, shoes, perfume, and even cell phones.

Nylon bag, 2008
This bag shows the signature nylon that Prada started using in the 1980s—as opposed to leather—giving them a reputation for innovation and modernity. Leather is used here for the handles and trimming.

Peacock skirt, 2005
One of Prada's most talked-about garments was this skirt from 2005, with real peacock feathers. Extravagant and technically difficult to produce, it pushed the boundaries between haute couture and ready-to-wear clothing.

Bottle top skirt, 2007

Miuccia Prada has said that the fabric is 90 percent of the work in clothing design, and the company works closely with Italian textile mills to produce unusual fabrics. This 2007 skirt shows off jewel-like aluminum decoration made from old-fashioned milk bottles.

Art nouveau tunic, 2008

In 2008, Prada worked with American artist James Jean to create a romantic mix of references for its summer collection. These combined the curved lines of art nouveau, the light fabrics of Ossie Clark used in the 1960s, and a fantasy world of fairies and flowers.

Contradictory fabric, 2007

Prada's 2007 collection featured 1940s turbans and day wear in duchess satin, a fabric normally reserved for evening. Miuccia Prada has said that it is contradictions such as this that make her work contemporary.

Ralph Lauren

Frontier, 2009
There is a frontier theme to this outfit of subtle colors, which contrast with the textures. The leather belt has an ornate silver buckle and the jacket is a patchwork of wools, but the dress is lightweight silk.

Ralph Lauren (b. 1939) has established clothing lines for men and women that evoke an idealized version of American history and culture. He first created the Polo menswear line in 1968 based on an Ivy League style: high class, sporty, and youthful. In 1972, he started his women's line using themes such as the Prairie and American Frontier. The clothes often have full skirts and are feminine or can be derived from the masculine. Lauren's designs have a reputation for quality fabrics in subtle colors.

Navajo, 2004
This is a large version of the silver Navajo belt Lauren first used in his Prairie Look collection in 1978. The minimalist skirt and top in beige jersey give maximum impact to the belt.

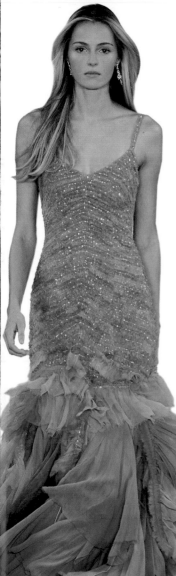

Denim, 2010 (left)
Denim, the American work wear fabric, has inspired this evening dress, but the textiles used are fine, lightweight silks and chiffons. The silks have been dyed to represent the different blues of faded denim and then decorated with silver.

Nautical, 2006 (right)
Military and nautical themes have inspired Lauren's collections. Here, there is a predominantly white cotton summer outfit accented with a striped top. It is an example of a fresh, sporty image.

Ivy League, 2010
The preppy elegance of the 1900s Ivy League style is represented in this outfit. The blazer is softly tailored so that the image remains young and sporty.

Yves Saint Laurent

In 1961, Yves Saint Laurent (1936–2008) started his fashion house with his business partner Pierre Bergé. As Dior's successor, Saint Laurent represented a link with the golden age of French fashion. He was known for the quality of his tailoring and, in particular, from 1966, for pantsuits. Themes from other cultures, such as Africa and Russia, inspired his collections.

Africa, 1967
These Africa-inspired outfits are silk, decorated with wooden beads and raffia. They show a youthful and modern approach, particularly in the minidress with its cutout midriff and short length.

Cocktail, ca. 1985 (right)
Saint Laurent received his first break when, as a teenager, he won first prize for designing a cocktail dress in a competition. This glamorous version is designed on the themes of curves and rich textures.

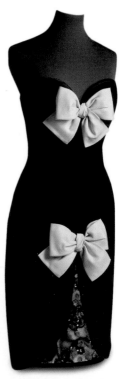

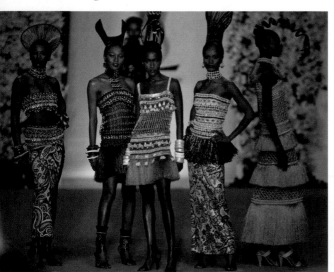

Appendices

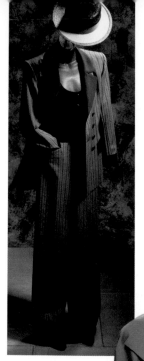

Hipster suit, 1994 (left)

From the 1960s onward, Saint Laurent produced versions of pantsuits that were derived from menswear. This is a three-piece suit of gray pinstripe, which was a traditionally male fabric.

Stefano Pilati, summer 2010

Stefano Pilati has been responsible for the prêt-à-porter collection Rive Gauche since 2000. He has said that for summer 2010, he was inspired by a new minimalism; here is an example that uses texture and one color with an accent brown belt.

S
summer

Pilati wa
fluidity
outfit o
worn wi
under a
jacket.
approach
by the co
and

Glossary

AESTHETIC DRESS in the second half of the 19th century, a movement was formed against the conventional tight-fitting clothes for men and women. They took inspiration from the Middle Ages for women's dresses and this type of gown was sold by Liberty's of London.

ANILINE DYES a group of synthetic fabric dyes that became commercially available in the 1850s

APPLIQUÉ a method of decorating fabric by applying other fabric shapes, or trims, onto the surface

BAR JACKET revived under John Galliano in 2004 but derives from 1947. Christian Dior gave individual names for each outfit. The most famous outfit from his first collection in 1947 was a full skirt and jacket, which was padded to emphasize the hips—he named the suit "Bar."

BEAVER CLOTH a type of heavy, wool twill double cloth, with a surface that is sheared to give a smooth, dense nap. With its soft body and long nap, it can resemble fur. Can also refer to a plush fabric used for hats.

BIAS the thread line at a 45-degree angle to the lengthwise and crosswise grain of the fabric

BLAZER a jacket, that is more often double-breasted than single-breasted, and traditionally in navy with metal buttons. The design derives from a jacket worn by the British Navy during the 19th century.

BLONDE LACE in the early 19th century, some silk lace was made from unbleached thread, hence its beige color.

BODICE the top half of a dress from shoulder to waist

BRILLIANT CUT often used for diamonds, a form of gem cutting where the upper stone is cut into about thirty-three facets and the lower part into twenty-five facets.

BROCADE a weave for a silk fabric that has a pattern, usually floral, made by wefts that go only the width of the motif, then are turned back. It can have the appearance of embroidery. The background weave can be plain, twill, or satin.

BUSTLE a structure worn at the back to hold out the skirt. Bustles varied in size from a small cushion to a curved frame from waist to calf.

CABOCHON a gemstone that is shaped and polished but not cut into facets.

CAPRI PANTS narrow-leg pants that end around calf level, often with a small slit in the side seams, fashionable in the 1950s. Designed and named by Emilio Pucci, whose fashion business was based on the Italian island of Capri.

CHIFFON a weave that produces a sheer soft fabric that drapes particularly well

COCKTAIL DRESS a dress, short or long, less formal than the full-length evening dress and particularly popular in the 1950s

COMBAT PANTS loose, casual pants with large pockets on the legs based on military styles

CORSET a close-fitting, boned undergarment worn to create a particular top-body shape usually with the aid of lacing

COTTON JEAN a hardwearing twill weave cotton derived from *jene fustian*, a coarse fabric made in Genoa in the 16th century. By the 20th century, pants made of this work wear fabric were known as "jeans."

CRAVAT a long strip of fabric wound around the neck and tied in front, usually with different knots or bows

CREPE a weave that produces a fabric that is matte with a crinkly texture and that drapes well

CRINOLINE originally a fabric, "crin," made from horsehair and cotton or linen, used to stiffen petticoats. In 1856, it described a bell-shaped understructure, usually made of steel, that replaced layers of petticoats to support a skirt.

DART a tapered tuck of material incorporated to help the fabric fit the curves of the body

DENIM literally "de Nîme," from the town in France known in the 18th century for the production of hard-wearing cotton. Denim has a twill weave with a fine diagonal ribbed appearance.

DJELLABA a long loose garment with a hood and sleeves worn in Arab countries

EMPIRE LINE refers to Napoleon I's empire, when the style of a woman's dress was cut with a high waistline under the bust

FAILLE a weave that produces a fabric that can have luster, with very fine flat crosswise ribs. It is lightweight and soft but firm.

FICHU a scarf or shawl worn around the shoulders popular in the 18th century, made of fine linen, cotton, or lace

FLANNEL a fabric, usually wool, with a plain or twill weave, with a soft fuzzy surface. It originated in Wales from the Welsh name for wool, "gwlanen."

FOB ornament for men that was suspended from a chain, popular in the 19th century

FROCK COAT in the 19th century, this became a formal coat with a neat fitted body and full skirts.

GABARDINE a twill weave in which the fabric has fine diagonal lines on the right side. It has some body, resists creasing, and drapes well.

GARÇONNE first used in the 1920s in France to describe the new type of young women who started dressing in men's clothing, particularly pants, and cutting their hair very short

GAZAR a weave related to organza, but the fabric is more tightly woven and, therefore, more stable. Silk gazar is an expensive fabric that is sheer and crisp; it is shiny on one side and dull on the other.

GODET a piece of material added to give fullness, often a triangle

GORED SKIRT A skirt, usually A line, with shaped panels from waistband to hem. Gores add fullness without the need for bulky pleating or gathering at the waist.

GROSGRAIN a closely woven fabric with narrow horizontal ribs often used for ribbons.

HAUTE COUTURE the highest quality clothing for women, which has had a different meaning since the introduction of prêt-à-porter collections between the 1950s and 1970s. Rules governing houses that have the right to show haute couture collections, in Paris, are under the control of the Federation of French Fashion.

JERSEY a stretchy, lightweight single-knit fabric of any fiber that is used to create fluid styles by gathering or draping the cloth.

KAFTAN a loose, ankle-length garment with long or elbow-length sleeves from eastern Mediterranean countries. The garment was popular in the West in the late 1960s and 1970s, and regarded as bohemian.

LAMÉ a woven fabric with metallic threads

LAST the rough form of the human foot on which shoes are constructed

LUREX a type of metallic thread

MOIRÉ a finish that gives fabric a watered, wavy appearance

NAP pile or surface of a fabric, obvious in weaves, such as velvet, where the long threads protrude on the surface

NEHRU COLLAR a short, standing collar, usually in men's wear, derived from Indian clothing and popular in the West in the 1960s

NEOCLASSICAL literally "new classical"—the dominant style in architecture, design, and clothing in both the late 18th and early 19th centuries

NORFOLK JACKET a jacket, often made of tweed, that had stitched-down box pleats at front, sides, and center back with a belt, all of matching fabric. It was popular in the second half of the 19th century for sports and casual wear, and was worn by men and women.

ORGANZA a weave for silk that produces a sheer, crisp fabric.

PANNIER French for basket— used for the understructure, worn in the 18th century, holding the skirt fabric out away from the hips in an exaggerated shape.

PARURE French term for a set of jewelry—several matching items worn together

PATCH POCKET a pocket shape that is applied to the outside of a garment, often a sports jacket

POLONAISE the name for a type of 18th-century gown in which the skirt was pulled up to form a pouf shape, leaving a curved hem that revealed the wearer's petticoat underneath

Glossary

PEPLUM an extra, shaped piece of fabric attached at the waist to the bodice of blouse or jacket, usually flaring out to cover the hips

PRÊT-À-PORTER a French translation of the term "ready-to-wear" created to give a more positive image to mass-produced clothing in France. A collection of clothing produced twice a year in a range of sizes.

PRINCESS LINE a cut for a dress without a waist seam but with panels from shoulder to hem

RAYON the first man-made fiber, produced from cellulose, at the end of the 19th century as an artificial silk

REEFER JACKET a double-breasted jacket, originally navy blue, derived from jackets worn by the British navy. Popular in the late 19th century for men's wear and revived in the 1960s for men and women.

RETICULE small purse used in the early 19th century.

ROSE CUT gem cutting with a flat base and triangular facets that rise to a point

RUCHED fabric that is gathered between lines of stitches

RUSSIA BRAID a narrow, military-style trim consisting of two parallel cores covered with fine yarn, which was often gold or silver in color

SACK-BACK GOWN a type of 18th-century gown, which, at the back, stood away from the body in a long, loose drape, and is gathered or pleated at the shoulders.

SAVILE ROW an area of London, near Piccadilly, where a concentration of tailors developed in the 19th century

SHIBORI a Japanese method of decoratively dyeing textiles by folding, binding, twisting, and stitching fabric

SMOCKING decorative stitching that creates a pattern across gathered fabric

SMOKING JACKET a soft, unstructured jacket that was originally worn for smoking at home in the second half of the 19th century

STILETTO describes the heel of a shoe; the term can refer to a shoe with a variety of upper designs provided the heel itself ends in a point with a small diameter.

STOCK a neck cloth, fastening at the back, worn from the 18th century onward

TAILCOAT a man's coat that finishes at the waist in the front but at the knee in the back; worn since the 19th century, particularly for evening wear.

TEA GOWN a loose gown of rich silk and lace popular in the late 19th century particularly for informal gatherings at home

TOILE DE JOUY today may refer to any cotton printed in a single color with floral or scenic motifs and in the past produced in Jouy near Versailles, France

TAFFETA a weave used for silk and synthetic fabrics that produces a crisp, smooth fabric with a sheen. It is often produced with warp and weft threads of different colors, which is called a "shot effect."

TRENCH COAT a raincoat for men and women, named because of its use by soldiers in the World War II

TRILBY a man's hat with a narrow brim and creased crown

TROMPE L'ŒIL a French expression that literally means "to deceive the eye," and an effect used in dress that has been inspired by surrealism. See designers Elsa Schiaparelli and Sonia Rykiel.

TWEED originally referred to rough-textured woolen fabric woven near the River Tweed, between Scotland and England that had colorful slubs (a thick nub in the yarn) on the surface. Today, it can mean any fabric with this appearance.

TULLE a fine machine-made net of silk or synthetic fibers originally made in Tulle, France in the early 19th century

VELVET a weave in which the pile is long, standing up above the surface of the fabric.

WARP threads running lengthwise on a loom

WEFT threads carried widthwise across the loom in a shuttle by the weaver

Resources

Books

Breward, Christopher, *Fashion*, Oxford University Press, 2003.

Breward, Christopher, Ehrman, Edwina and Evans, Caroline, *The London Look*, Yale University Press, 2004.

Breward, Christopher, Gilbert, David and Lister, Jenny, *Swinging Sixties*, V&A Publications, 2006.

Chenoune, Farid, *A History of Men's Fashion*, Flammarion, 1996.

Chenoune, Farid, *Yves Saint Laurent*, Harry N. Abrams, 2010.

Corson, Richard, *Fashions in Makeup*, Peter Owen, 2004.

Cox, Caroline, *Hair & Fashion*, V&A Publications, 2005.

Davies, Hywel, *Modern Menswear*, Laurence King, 2009.

De La Haye, Amy, *The Cutting Edge*, V&A Publications, 1998.

Fukai, Akiko and Suoh, Tamami, *Fashion: A history of 18th Century to 20th Century*, Barnes & Noble, 2006.

Harris, Jennifer, ed., *5,000 Years of Textiles*, Smithsonian Books, 2011.

Johnston, Lucy, *Nineteenth-Century Fashion in Detail*, V&A Publications, 2009.

Lacroix, Christian, *On Fashion*, Thames & Hudson, 2009.

McDowell, Colin, *The Man of Fashion*, Thames & Hudson, 1997.

Miller, Lesley Ellis, *Balenciaga*, V&A Publications, 2007.

O'Hara Callan, Georgina and Glover, Cat, *Fashion and Fashion Designers*, Thames & Hudson, 2008.

Phillips, Clare, *Jewelry: From Antiquity to the Present*, Thames & Hudson, 1996.

Schoeser, Mary, *World Textiles: A Concise History*, Thames & Hudson, 2003.

Sherrow, Victoria, *Encyclopedia of Hair*, Greenwood Press, 2006.

Steele, Valerie, *Fashion Italian Style*, Yale University Press, 2003.

Storey, Nicholas, *History of Men's Fashion*, Remember When, 2009.

Wilcox, Claire and Mendes, Valerie, *Twentieth Century Fashion in Detail*, V&A Publications, 2009.

Web sites

WWW.LESARTSDECORATIFS.FR

WWW.METMUSEUM.ORG/WORKS_OF_ART/THE_COSTUME_INSTITUTE

WWW.MODEAPARIS.COM

WWW.STYLE.COM

WWW.VAM.CO.UK

Index

Index

Acknowledgments

AUTHOR ACKNOWLEDGMENTS

I would like to thank Caroline Earle and everybody at Ivy Press for their help in preparing this book. Information about items in the V&A Collections was found on their excellent Web site and the many publications by Amy de la Haye, Lucy Johnston, Valerie Mendes, Lesley Ellis Miller, and Claire Wilcox. As can be seen in the Resources section, a wide range of sources were consulted to produce this work. Finally, thank you to friends and family for their encouragement and understanding.

PICTURE CREDITS

Special thanks to Elaine Lucas, Meghan Mazella, and Christopher Sutherns at V&A Images for all of their effort and support. The Ivy Press is also grateful to the following organizations for giving permission to feature their work: Cartier, Fundació Gala-Salvador Dalí, Schiaparelli, Hans Stofer, Tiffany & Co., Van Cleef & Arples, and Vivienne Westwood.

All images courtesy of and © V&A Images, Victoria and Albert Museum, except for the following:

© Cecil Beaton, V&A Images, Victoria and Albert Museum: 4, 75L, 76L, 77TL, 90, 91TL, 93TL, 196, 197, 199R, 199BL, 213BR, 256.

Catwalking.com: 13R, 13L, 14R, 17R, 17C, 18R, 19CR, 21BR, 22L, 23R, 23C, 24R, 25C, 26L, 27C, 28L, 29L, 30L, 31R, 33R, 35L, 36L, 38L, 39L, 44, 45BR, 51C, 63L, 63R, 65R, 67R, 68, 71R, 75R, 75C, 79L, 80R, 81L, 82R, 85R, 85C, 87R, 93BL, 94R, 97R, 98L, 101L, 102R, 103, 103C, 105L, 105R, 108, 110R, 111R, 111C, 112R, 115L, 115R, 116L, 117C, 118L, 119C, 121C, 121R, 122L, 123R, 123L, 126L, 127C, 127L, 128R, 128L, 129R, 129L, 130L, 131R, 132L, 133L, 133R, 133C, 134R, 135TL, 136L, 138R, 142L, 143C, 145R, 147L, 148R, 150L, 151R, 157R, 158R, 161R, 163C, 171BR, 172L, 173TR, 175TL, 175R, 177L, 179R, 183TL, 183BC, 183TR, 185R, 189BR, 190R, 193R, 194R, 209R, 217BL, 218R, 219TC, 221T, 223R, 223TL, 226R, 227C, 227R, 233R, 233C, 235C, 235L, 236, 237R, 237C, 238, 239L, 240, 241, 242, 243R, 243L, 245R, 245C.

Corbis: 33L: Bettmann: 32R, 24L, 167R; Kipa: 213TR; Kurt Krieger: 216L; Bob Linder/Sygma: 214L; Toby Melville/Reuters: 223BL; Sunset Boulevard: 110L, 219L; Sion Touhig/Sygma: 209BL; Pierre Vauthey/Sygma: 232L; WWD/Condé Nast: 186, 243C, 244L.

© John French, V&A Images, Victoria and Albert Museum: 1, 5, 27R, 54, 71L, 89, 99R, 125, 129TC, 134L, 137L, 155, 157C, 160R, 166R, 180, 181, 182, 193BL, 193TL, 221R.

Getty Images: 163R, 220R, 222R; AFP: 239BR; Apic: 47L; Dave Bennett: 96R; Junko Kimura: 34BL; Donato Sardella/WireImage: 205TL; Time & Life Pictures: 184L, 229TL, 239TR.

© Harry Hammond, V&A Images, V&A Theatre Collections: 37L, 72, 78L, 88, 102L, 109BR, 118R, 126R, 136R, 147TR, 168, 176, 177TR, 179BL, 210, 211, 212R, 217TL, 217R.

The Kobal Collection/Paramount: 7, 124, 135B, 170L.

Made by Sue Lawty: 62TL.

Courtesy Levi Strauss & Co. Archives, San Francisco: 116R.

Mary Evans Picture Library: 23L; National Magazine Company: 91TR, 160L.

© Andrew Pitcairn Knowles, V&A Images, Victoria and Albert Museum: 140, 150R, 163L.

Rex Features/Jeanette Jones: 153R; Sipa Press: 204R.

RMN/Droits réservés: 229TR.

Schiaparelli France SAS: 12R, 29T, 53TL, 57BL, 139R, 195TR, 198TL.

Courtesy Schott NYC: 114L.

Courtesy John Smedley: 152R.

Topfoto: 117R.

Every effort has been made to acknowledge the pictures, however, we apologise if there are any unintentional omissions.